IMAGES
of America

HISTORIC HOUSES
OF QUEENS

IMAGES
of America

HISTORIC HOUSES OF QUEENS

Rob MacKay

ARCADIA
PUBLISHING

Published by Arcadia Publishing
Charleston, South Carolina

Printed in the United States of America

Library of Congress Control Number: 2020952035

For all general information, please contact Arcadia Publishing:
Telephone 843-853-2070
Fax 843-853-0044
E-mail sales@arcadiapublishing.com
For customer service and orders:
Toll-Free 1-888-313-2665

Visit us on the Internet at www.arcadiapublishing.com

This book is dedicated to Asha and Sarika MacKay.

CONTENTS

ACKNOWLEDGMENTS

With all respect to the phrase "it takes a village to raise a child," it took an entire borough to write this book. Between the research, photographs, and fact-checking, I am in great debt to many people and institutions, but before sharing the list, I would like to offer special, heartfelt thanks to everybody who helped me on this journey. I learned a lot about history, demographics, architecture, and urban planning while writing this book, but most importantly, I learned that this world is full of wonderful people who are happy to lend their time and expertise to a good cause. Thanks and more thanks to Bob Singleton, Branka Duknic, Caitrin Cunningham, Carl Ballenas, Charlotte Jackson, Daniela Addamo, Erik Huber, Ewa Kern Jedrychowska, Harvey Ngai, Howard Kroplick, James Jürgen, James Trent, Jason Antos, John Choe, Karolina Rostafinski Merk, Kelsey Brow, Linda Monte, Marion Duckworth Smith, Matthew A. Postal, Michael Perlman, Nicholas E. Torello, Ran Yan, Ricky Riccardi (also known as "Ric-O-Pedia"), Robert and Susanna Hof, Rosemary Vietor, Sarah Meyer, Seth Bornstein, Sharmeela Mediratta, Steve Monte, and Tom Leverich. Then there are the nonprofit and government agencies that provided many of the images. My gratitude goes to Bayside Historical Society, Bowne House Historical Society (BHHS), Flushing Quaker Meeting House, Greater Astoria Historical Society (GAHS), Greater Ridgewood Historical Society (GRHS), King Manor Museum (KMM), Lewis Latimer House Museum, Library of Congress (LOC), Louis Armstrong House Museum (LAHM), National Park Service (NPS), New-York Historical Society (NYHS), New York Public Library (NYPL), New York State Archives (NYSA), NYC Landmarks Preservation Commission (NYC LPC), New York City Municipal Archives (NYCMA), Queens Historical Society (QHS), Queens Economic Development Corporation, Queens Public Library (QPL), Queens Tourism Council (QTC), Richmond Hill Historical Society, Municipal Art Society of New York, United Nations (UN), and Voelker Orth Museum, Bird Sanctuary and Victorian Garden (VOM). These abbreviations appear in the image courtesies, as do those of Carl Ballenas (CB), Jason Antos (JA), and Marion Duckworth Smith (MDS).

INTRODUCTION

The phrase "Home Sweet Home" entered into common English parlance thanks to an 1822 song adapted from an opera by New York–born John Howard Payne that features the immortal stanza, "Be it ever so humble, there's no place like home."

With a melody by English composer Sir Henry Rowley Bishop, the ballad was an international hit for several decades and was translated into many languages and even featured in the soundtrack for one of the first major silent movies. Everybody could relate to the lyrics because homes are the foundations of life. In addition to providing shelter and safety, they are where families bond, children become adults, traditions are observed, and indelible memories are made. And in some cases, they are beautiful works that magically combine architecture, carpentry, masonry, painting, and creative vision.

According to the US Census, there were more than 2.2 million people living in 869,400 household units in Queens in 2018. These units include everything from drab apartments in public housing projects to nondescript attached row houses to sprawling, awe-inspiring mansions. But regardless of their market values, they all have their own triumphs, tragedies, and tales.

This book explores notable houses in Queens over the past four centuries. Most are landmarks, as well as a few that did not obtain that status despite community efforts. With more than 200 images, these pages look at their designers, their owners, their neighborhoods, their peculiarities, and even their fates while always considering that real humans lived in them. They grew up in them. They relaxed in them. They proudly showed them to friends and family. And in some cases, they lost them to financial problems or fires.

The text and photographs begin in the borough's north-central peak, East Elmhurst, where New York City's oldest private dwelling still stands. The book continues clockwise to northeast Queens before swinging down to the still-suburban southeast sections and the Rockaways at the extreme south. Then, the chapters follow a circuitous route through the east and up before ending a few blocks from where it began. Geography is an exact science, but this book does not make any straight lines, so the reader's imagination might be pressed as the tour zigzags back and forth.

The general history is not much different from other areas in the Northeastern United States. Queens received its name from Catherine of Braganza, a Portuguese royal who was British King Charles II's wife, in 1683, just 19 years after England took over New York and established the colony as part of its worldwide empire. At the time, the rural area was sparsely inhabited, mostly by members of the Lenape and Matinecock Tribes.

The first European settlers came from Holland and England in the 17th century. As no surprise, the first houses featured Dutch Revival and British Colonial architecture. Made from wood and stone, they had stoves and fireplaces but no heating or air conditioning systems. They were parts of large farms where entire families toiled alongside African American slaves and salaried white laborers. Residents were Quakers, Episcopalians, and members of the Dutch Reformed Church.

In the 18th century, technological advances allowed for mass manufacturing, which created incredible wealth for some businessmen and reduced the need for subsistence farming. Stables and orchards disappeared, while mansions popped up along shorelines and got bigger and bigger. Plus, German and Irish immigrants arrived in waves and incorporated new architectural styles and building techniques.

Soon, entire neighborhoods sprang up with paved roads, electric grids, sewers, potable water systems, and public transportation. The population boomed, and for better or worse, the borough was incorporated into the City of New York in 1898. Some rural areas quickly transformed into suburbs, while others became urban neighborhoods with sky-scraping apartment complexes. Still more became seaside summer paradises with long driveways and ocean breezes for extremely wealthy Manhattan families with cars.

The 20th century brought even more construction and inhabitants, including many African Americans, Eastern European Jews, Italians, Asians, and Latinos. Immigrants were establishing roots near John F. Kennedy International Airport, where they first entered the county. Phenomena from this period include Beaux-Arts architecture, government-run housing projects, restrictive covenants, sidewalk driveways, and "McMansions."

The march continues in the 21st century, and now, the densely populated hub is the most diverse county on the entire planet. About half of its residents were born outside the United States, and they speak an estimated 170 languages. Bustling neighborhoods have such nicknames as "Chinatown," "K-town," "La Pequeña Colombia," "Little Guyana," "Little India," "Little Manila," and "Little Pakistan." New community fights pit preservationists and urban planners against homeowners and developers who want to tear down residences and build bigger ones to meet demand.

Such is life, and Queens will certainly undergo many more changes in the future. However, the human desire for shelter in a place called home will carry on—and this desire will continue sparking human creativity.

Maybe a second book on Queens's historic houses will need to be written 400 years from now.

One

LONG-TERM IMPACTS

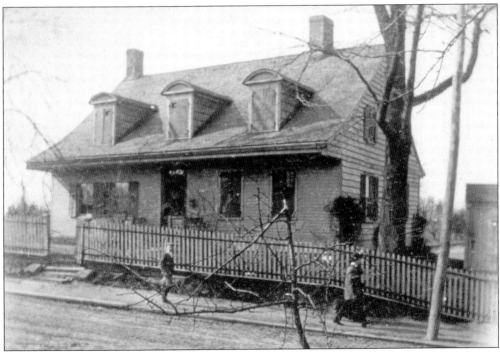

It is the oldest private dwelling in New York City that is still a dwelling, and only three families—the Rikers, that of William Gooth, and the Smiths—have owned this East Elmhurst residence since it was built in 1654. The Lent-Riker-Smith Homestead's story begins with Abraham Rycken, an immigrant from Lent, Holland, who constructed a one-room, timber-and-fieldstone farmhouse on a roughly one-acre parcel that New Amsterdam director-general Peter Stuyvesant had granted him. The simple abode underwent expansions in 1729 and about 1800 and is currently two stories high, covered in ivy on one wall, and painted yellow with crimson shutters. This image is from the 1920s. (MDS.)

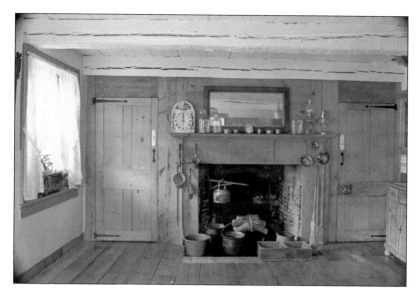

The original house consisted of nothing more than this "keeping room." In Colonial times, families would often sleep together in the same room as the fireplace during the cold winters. (MDS.)

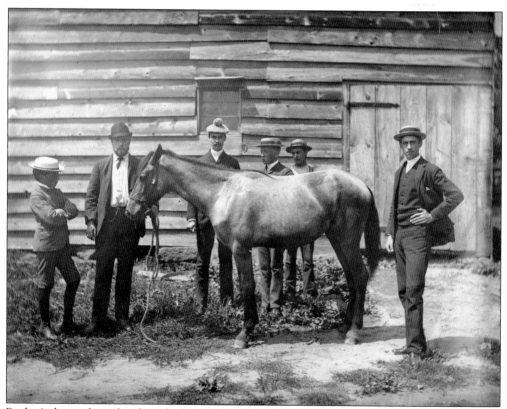

Rycker's descendants lived on the land for many generations and built several structures on the property, including this barn. Some were demolished, while the mansion on this book's cover was destroyed in a fire. Much of the land—including the parcels around the old mansion—now belongs to LaGuardia Airport. But the original house, the Lent-Riker-Smith Homestead, still stands near where Nineteenth Road and Nineteenth Avenue intersect. (MDS.)

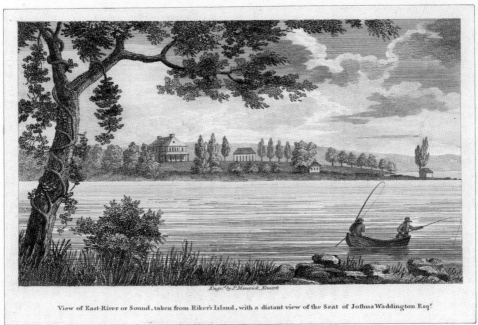

Engr.ᵈ by P. Maverick, Newark

View of East-River or Sound, taken from Riker's Island, with a distant view of the Seat of Joshua Waddington Esqʳ.

Flushing Bay

The Rikers also owned an island just to the north of their mainland property, and family members would use canoes to travel between the two sites. Rikers Island is now famous because it hosts New York City's main jail complex. The causeway to enter to complex runs by Lent-Riker-Smith Homestead's remaining estate. (NYPL.)

He had a lot of competition, but John Jackson Riker (1858–1932) was possibly the most prominent family member. He started as an office boy and climbed the ladder to become president of J.L. & D.S. Riker, a family merchant company that focused on the chemicals trade. He also sat on the boards of various private-sector entities, such as the Hanover National Bank and Atlantic Mutual Insurance Company, and rose from private to major in the New York National Guard. A member of the New York Yacht Club and Apawamis Club in Westchester County, John Jackson Riker also served as the local sheriff. He is 25 in the photograph at left from 1883, and 56 below in 1914. (Both, MDS.)

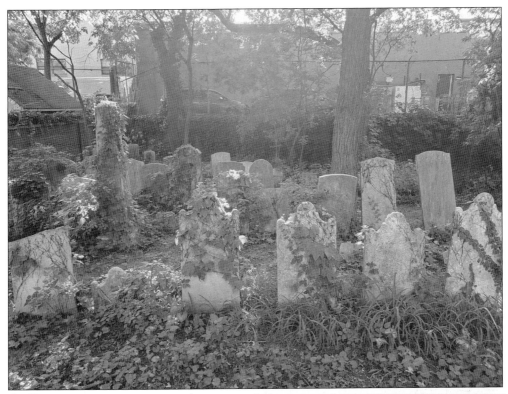

A 132-grave cemetery remains on the west side of the property. The earliest tombstone dates to 1744, and most have the last names Riker or Lent. One cenotaph states that the deceased man "served his country nobly in the war of the Revolution and died at Valley Forge May 7, 1778, in his 38th year." The most whimsical gravestone features a carved image of a dog. According to legend, it honors a one-time caretaker, Rudolph Heinrich Durheim (1875–1944), who had 47 dogs and 33 cats. (Above, QTC; right, MDS.)

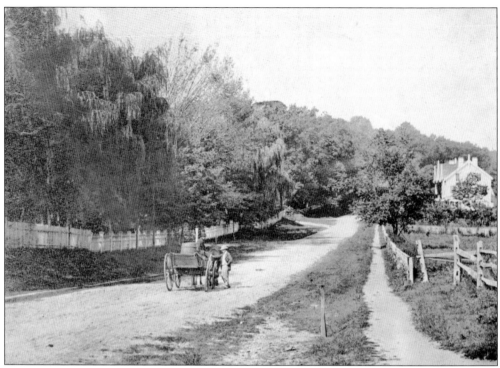

The Riker family operated their farm until 1938, when much of the land and the island were sold to New York City. Around this time, William Gooth, who had been an accountant and personal secretary for the family, bought the estate. He rented it out to a few people, including Jack Russell, a baritone who performed on Sid Caesar's *Your Show of Shows*. The image below is a depiction of the house in an 1877 painting by William R. Miller (Both, MDS.)

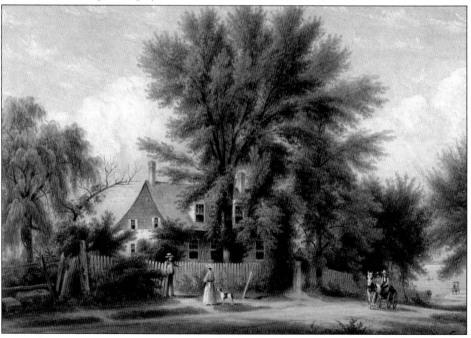

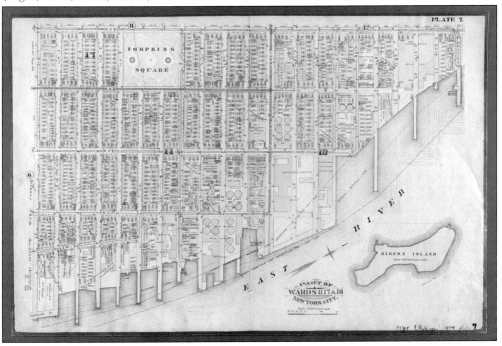

Although located next to booming Manhattan, Queens remained rural well into the 20th century. The ledger at right shows the farm's business activities. The map below is from 1885 and shows how urban life was taking over the Lent-Riker-Smith Homestead. Consolidated Edison, a public utility, owned much of the nearby land. Tract housing was being built, and eminent domain acquisition of part of the area was about to happen to build LaGuardia Airport. (Right, MDS; below, NYPL.)

15

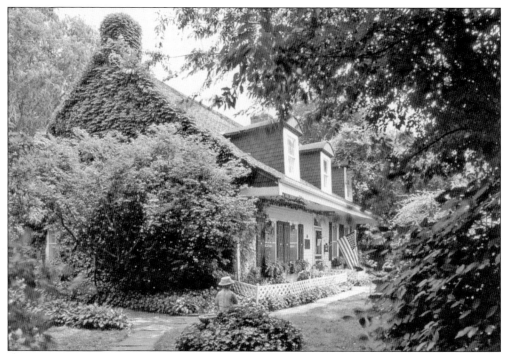

When Gooth discovered that he could not legally relocate the house, he sold the estate to his renter, Michael M. Smith, in 1975. Smith later married Marion Duckworth Smith, who still lives there today. She undertook most of the restoration and proudly states that one day she will rest eternally in the site's graveyard, right next to her husband, mother, brother, and sister, who are already there. She stands at her double Dutch front door before a tour below. (Both, MDS.)

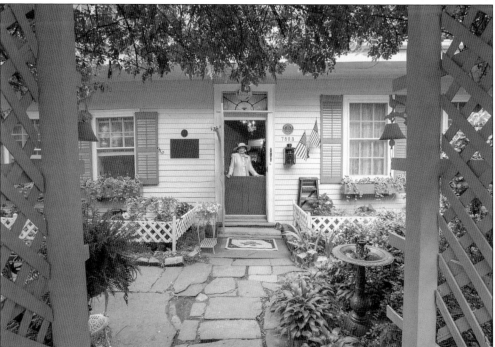

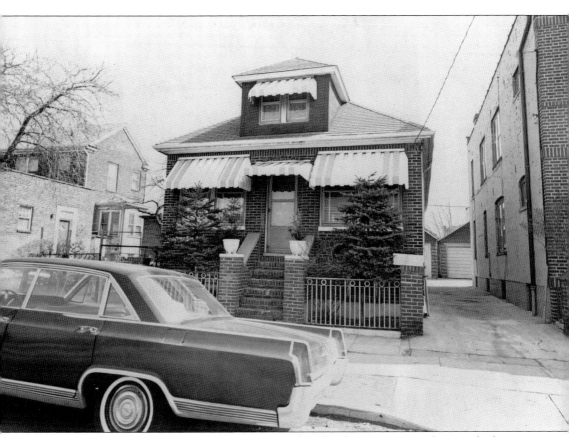

Malcolm X preached to his congregation, organized civil rights activities, and succumbed to an assassin's bullet in Harlem, but he lived in East Elmhurst during much of his professional life. Shortly after marrying Betty Shabazz, they moved into a two-bedroom detached brick house with one bathroom, a small living room, a dining room, a kitchen, and a utility room in 1960. Four of their daughters—Attallah, Qubilah, Ilyasah, and Gamilan—were born in Queens. (Their other daughters, twins Malaak and Malikah, were born after his death.) Just like today, East Elmhurst was a middle-class, largely African American neighborhood when Malcolm X's family lived there. Other prominent former residents include New York Giants baseball player Willie Mays, Harlem Renaissance writer Langston Hughes, and Eric Holder, who served as US attorney general during the Obama Administration. (LOC.)

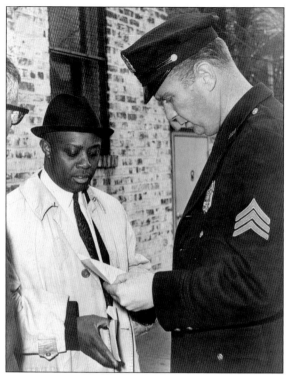

James 3X shows a court order to take possession of Malcolm X's house in the 1965 photograph at left. A few months before, the Nation of Islam had stripped Malcolm X of his job titles and installed James 3X, who was born James Russell McGregor, as the new minister of Mosque No. 7 in Harlem. The Nation of Islam claimed that the home was for employees, while Malcolm X sustained that he had received it as a gift. As seen below, two Molotov cocktails shattered the house's windows just before a fire engulfed the walls on February 14, 1965, at about 2:45 a.m. Malcolm X and his family escaped with minor injuries, but the structure sustained severe smoke and water damage. Malcolm X was evicted four days later and killed on February 21. (Both, LOC.)

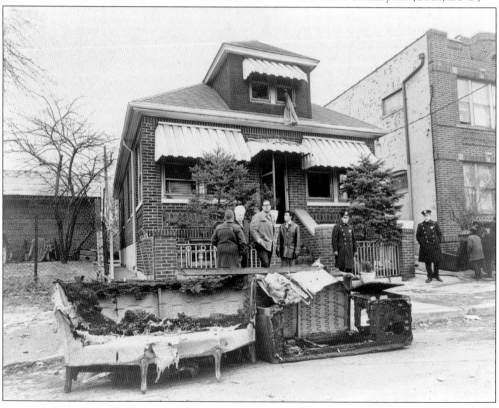

In 2005, city council member Hiram Monserrate led a successful effort to co-name the block Malcolm X Place, but the house does not have landmark status from any government agency. The owners of the private residence, which is currently seafoam green and located at 23-11 Ninety-Seventh Street, have no plans to sell it. (QTC.)

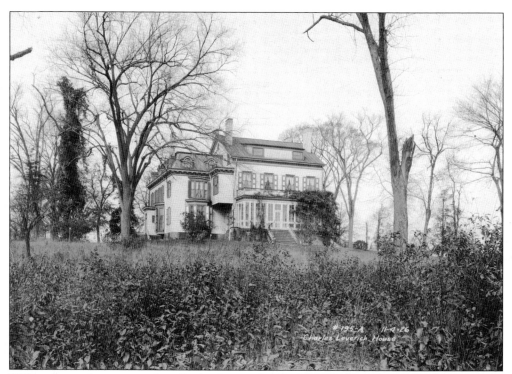

William Leverich, a minister from England, arrived in the New World in 1633 and bought farmland in the Trains Meadow section of what is now Jackson Heights. His descendants lived there for several generations and centuries, starting with his son Caleb, who constructed a two-story, high-ceilinged Colonial on the south side of Trains Meadow Road in 1670. Other Leveriches who built mansions include Charles, who ran a successful commission and factorage business with three brothers. In 1841, Charles bought 16 acres and built Fair View (seen above in 1926) in the vicinity of present-day Elmhurst Avenue and Ninety-Third Street. None of these structures remains today, although there is a Leverich Street and the Leverich Family Burial Ground near Thirty-Fifth Avenue. Nestled among residential homes and small businesses, the rectangular plot has no visible headstones these days, but it is a source of local pride. (Both, QPL.)

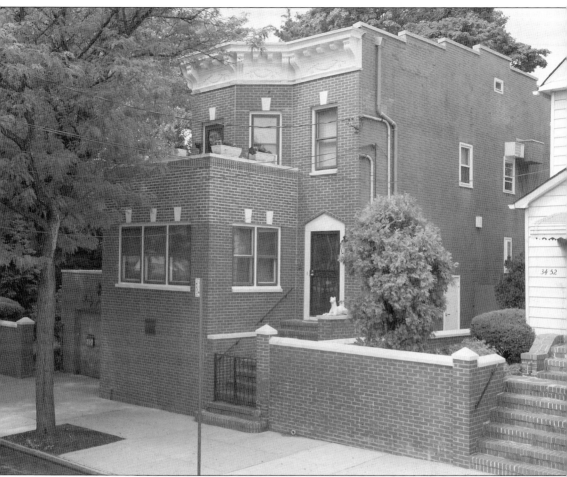

Louis Armstrong is often associated with New Orleans. After all, the jazz legend grew up in the Big Easy, where the international airport currently bears his name. But the only piece of land that "Satchmo" ever owned is in Corona, a residential Queens neighborhood. Because he was on a tour, the trumpeter did not even see the two-story, unattached brick house before his fourth wife, Lucille (née Wilson), bought it for about $8,000 in 1943. Nevertheless, he frequently described a love-at-first-sight moment when the taxi driver took him there for the first time. Lucille, a former singer at Harlem's Cotton Club, outlived him and donated the property to the city for use as a museum upon her death in 1983. (LAHM.)

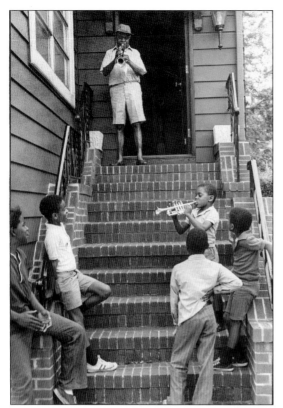

Armstrong's rough childhood included his father's temporary abandonment, his mother's health problems, and a stint at the Colored Waifs Home for Boys. The stress, poverty, and low-quality food led to a history of intestinal problems. So once he could afford it, Satchmo built the nicest bathroom money could buy (below). He installed floor-to-ceiling mirrors, onyx fixtures, a marble bathtub, and gold-plated faucets in the form of swans on a marble sink that was once a birdbath in France. He added speakers so he could listen to music while on the toilet. Armstrong traveled about 300 days a year during his heyday, so he cherished the hours he spent at his Corona stoop, often describing his "love affair" with his block. In a 1968 interview, Armstrong talked about the children he had watched grow up and how they called him and his wife "Uncle Satchmo" and "Aunt Lucille." (Both, LAHM.)

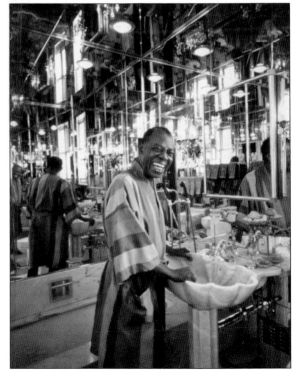

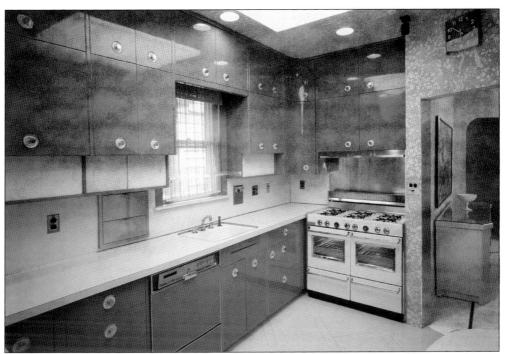

Lucille worked with Morris Grossberg, one of the day's hottest interior designers, to decorate the house. This collaboration is on full display in the Mid-Century Modern kitchen (above), which was completed in 1970. Turquoise to match Lucille's Cadillac, it features lacquered wooden cabinets and mounted appliances, including a Nutone food processor. Dispensers for waxed paper and aluminum foil are built into the wall, and an attached chair converts into a stepstool. (Louis was five foot, four inches, and Lucille was five foot, one inch.) The early-1960s Sub Zero refrigerator and the Crown deluxe stove are also part of the color scheme, and like the other appliances, they still work today. The Armstrongs never had children, but their house was always full of guests. The below photograph is from a Thanksgiving dinner in the 1950s. Velma Middleton, a vocalist with Satchmo for years, is to his right. (Both, LAHM.)

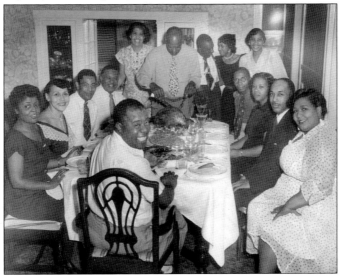

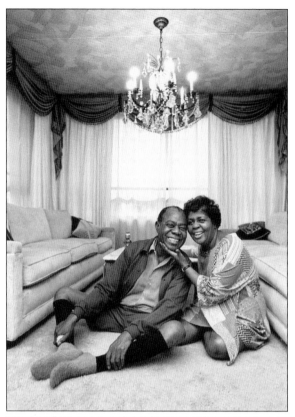

Nobody else lived in this national and city landmark at 34-56 107th Street after the Armstrongs, so the inside is just like it was when they lived there. For example, the master bathroom is decked out with silver Mylar wallpaper, which gives the appearance of foil. The wallpaper actually appears to have a mind of its own, extending to the dressing room, where it is on the cabinets and drawers. Louis used to say that Lucille took care of the interior design, but she let him have the den on the second floor. He kept scrapbooks, manuscripts, art, and audio recordings in his "man cave." (Both, LAHM.)

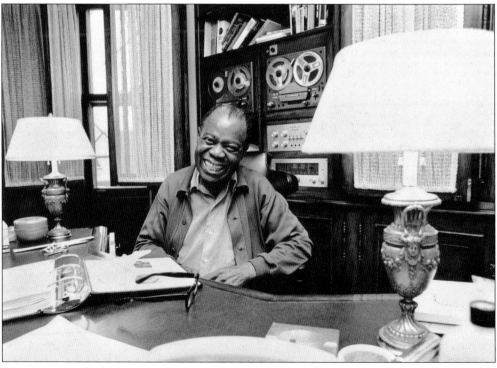

Two

ALMOST ROYAL FLUSH

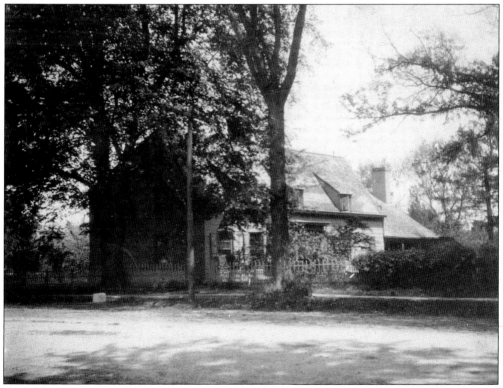

English immigrant John Bowne purchased about nine acres of farmland and built a modest dwelling in Flushing in 1661. He then married Hannah Feake, who gave birth to eight children. Thus began the streak. Nine generations of descendants lived in the wooden-frame English Colonial saltbox until 1945, when they donated the property to the Bowne House Historical Society for use as a museum. A New York City landmark that is listed in the National Register of Historic Places, the house is the oldest remaining domicile in Queens. This photograph is from 1899. (BHHS.)

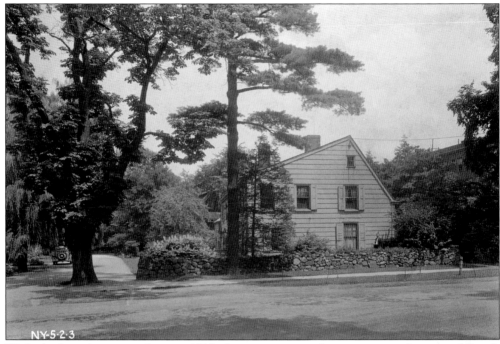

With the last alterations done in 1815, the structure combines common features of Dutch architecture and English building techniques with a pitched roof and three dormers. Inside, the permanent collection includes roughly 5,000 objects (furniture, clothes, textiles) that family members acquired over more than three centuries. The namesake family was so prominent for so many years that the property is located on Bowne Street, which stretches about two miles from one side of Flushing to the other. (Both, LOC.)

The china cabinet is seen in the 1897 photograph at right, and the dining room appears in the 1899 photograph below. The Bownes ardently opposed slavery, and the room near the dining room was either a stop on the Underground Railroad or a space where escaped slaves hid from bounty hunters (stories differ). In 1814, Ann and Catharine Bowne helped found the Flushing Female Association, an integrated school that educated African American children at a time when the area had no free public schools. (Both, BHHS.)

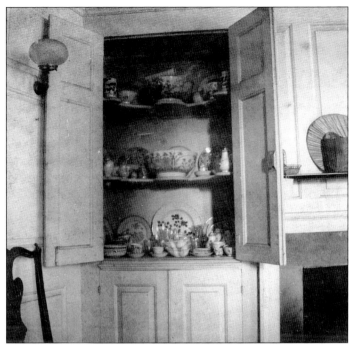

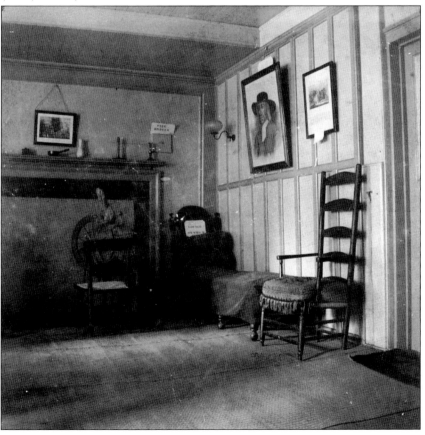

Rhode Island senator Jonathan Chace and Anne Moon Chace, who comes from the prominent Philadelphia Haines family that intermarried with the Bownes, are in the 1897 photograph above. Below, Judge Charles S. Colden stands at center among unidentified people in a c. 1950 photograph. (The two women are probably hostesses.) Judge Colden helped found the Bowne House Historical Society and establish the property as a national landmark. He was also involved in founding Queens College. (Above, BHHS; below, NYCMA.)

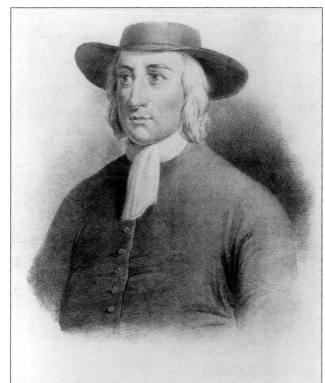

George Fox (1614–1691) was a main proponent of the Religious Society of Friends, or Quakers. Born in England, he made many tours through his native country and the New World to spread the word. When in New York City, he often stayed at the Bowne House as they were Quakers, too. The 1897 photograph below shows the room where he slept. (Left, NYSA; below, BHHS.)

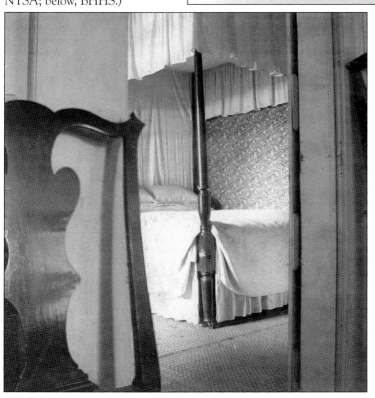

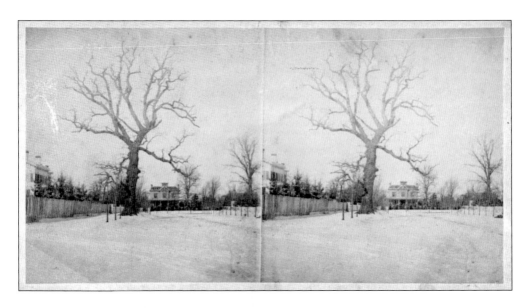

According to legend, George Fox gave a famous, convincing sermon under two oak trees in Flushing in 1672. The land was part of John Bowne's garden at the time. One oak died in 1841. The other, which is seen above, fell in 1863. The rock in the photograph below has a carving that commemorates the sermon. It is across the street from the historic house, which is located at 37-01 Bowne Street. (Above, LOC; below, QTC.)

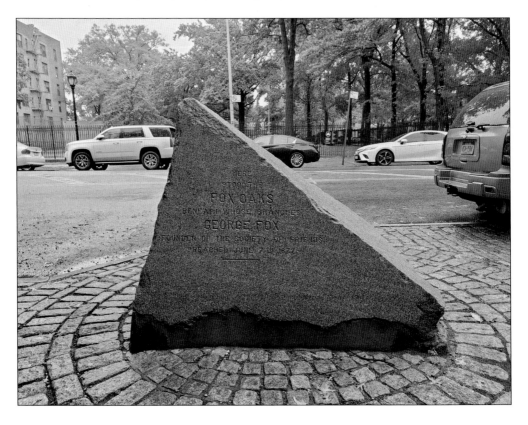

John Bowne did not sign it, but he hosted the town meetings that led to the Flushing Remonstrance, a 1657 petition to New Netherlands director-general Peter Stuyvesant requesting freedom to worship. At the time, the Dutch Reformed Church was the only permitted religion, and Quakers had to hold clandestine services in the Flushing woods while pretending to work the land. Upon hearing about the document, which had 30 signatures, Stuyvesant arrested Bowne and exiled him to Holland in 1662. The plan backfired, though, as Bowne filed direct appeals to the Dutch West India Company, which ordered Stuyvesant to allow total religious freedom in the colony. Historians regard the Flushing Remonstrance as the model for parts of the US Constitution's Bill of Rights. The document is on display in Albany, where it was damaged in a 1911 fire. (Both, BHHS.)

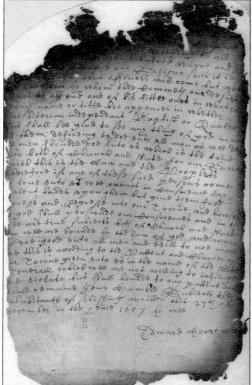

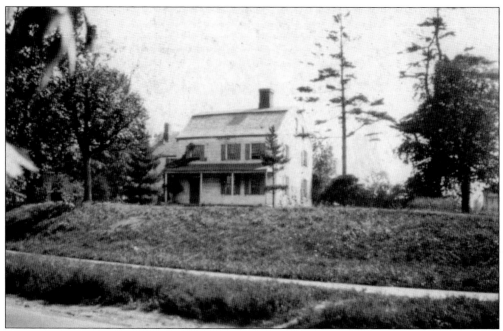

Kingsland Homestead was built by Charles Doughty, the son of a well-established Quaker, in the vicinity of Roosevelt Avenue and 154th Street in Flushing around 1785. His son-in-law, British sea captain Joseph King, purchased the two-story Long Island half house with a wide side hall and double parlors off to one side in 1801. It has a gambrel roof, a crescent-shaped window in a side gable, a Federal-period chimneypiece with an iron Franklin stove, and a Dutch-style, two-level front door. For years, it was believed the 12-room dwelling was named after its second owner. However, recent research has discovered that its moniker honors King George III of England. The photograph above is from 1922, and the drawing below is from 1950. (Above, JA; below, MCNY.)

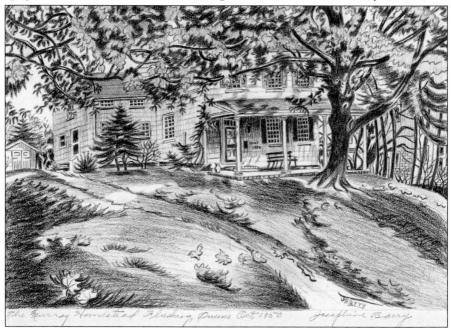

Captain King's daughter Mary Ann was the first Kingsland birth. She married Lindley Murray in 1831. (The Murray Hill neighborhoods in Manhattan and Queens are named after this prominent family.) The couple's oldest daughter, Mary, was an abolitionist who joined the Flushing Female Association, a Quaker group that built the area's only school for African American children. She lived most of her adult life in the attic, where she kept a diary whose surviving fragments tell the house's story. For example, it informs that a telephone was installed on January 15, 1903, while electric wiring came on June 5, 1906. The only surviving example of 18th-century architecture in Flushing, Kingsland is the current headquarters for the Queens Historical Society, which maintains a collection that includes textiles, art, photographs, maps, manuscripts, and family papers that encompass about 300 years of local life. (Both, QHS.)

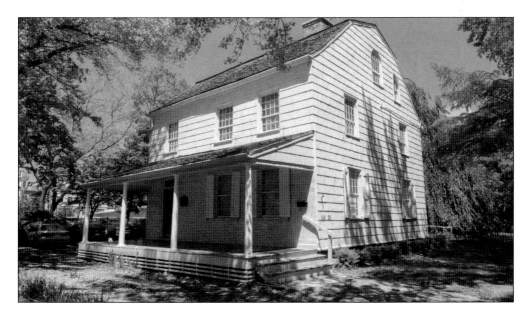

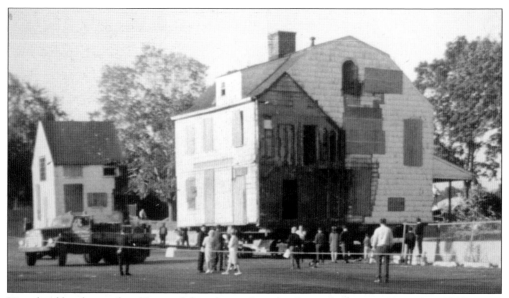

Kingsland has happy feet. To avoid demolition due to a planned subway extension in 1923, it was physically moved about one block to 40-25 155th Street, where Captain King had stables. (The 1923 subway expansion never happened, but the original site was subdivided into seven separate lots where brick houses were constructed.) Then, in October 1965, the New York City Landmarks Preservation Committee awarded landmark status and issued a Certificate of Appropriateness to relocate the structure about one mile to its current address at 143-35 Thirty-Seventh Avenue. Spearheaded by the Society for the Preservation of Long Island Antiquities and the newly formed Kingsland Preservation Committee, the move put Kingsland inside Weeping Beech Park and made it easier for the New York City Parks Department to maintain it. By 1971, the Kingsland Preservation Committee had evolved into the Queens Historical Society. (Both, JA, 1968.)

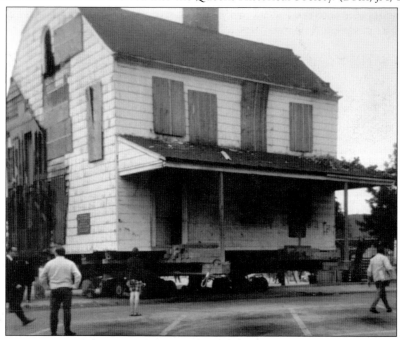

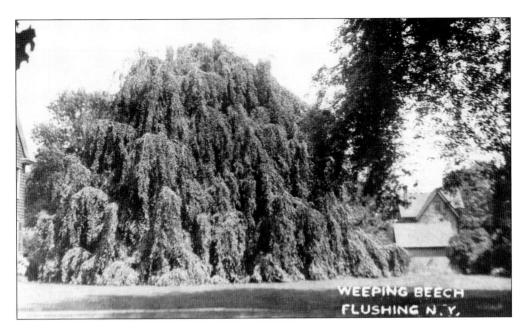

WEEPING BEECH
FLUSHING N. Y.

From the mid-1800s until 1998, a tree beautified Kingsland's backyard. The prized possession provided shade on summer days and displayed copper-toned leaves in autumn. It was the country's first weeping beech. The sapling began life on Baron DeMann's Belgian estate in 1847 before crossing the Atlantic as a four-inch cutting. It grew to 60 feet tall with a 14-foot circumference and 85-foot umbrella. Branches eventually re-rooted, begetting eight saplings that a horticulturist sent around the country. Over time, the descendants engendered more than one million children whose habitat currently stretches into Canada. In 1966, it was the first-ever living being to receive New York City landmark status. Soon after, it entered into decline, and though it received fertilizer injections, arborists declared it dead in 1998. Parks commissioner Henry Stern held a public funeral before it was chopped into parts. (Above, MCNY; below, QHS.)

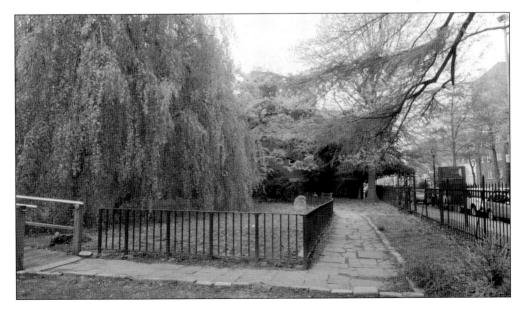

35

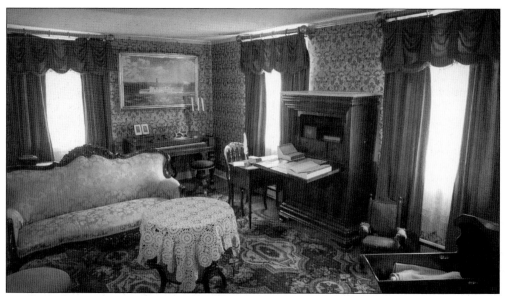

On the second floor, the Victorian Room (above) has a melodeon by Carhard, Needham & Co., lacework, and items such as family notebooks. Everything is arranged to reflect life in 1870, when 10 people—two young couples and their children—lived there. In the 19th century, it was believed that foot baths alleviated eye, head, and tooth pain while also healing certain illnesses. Captain King loved his foot tub (below), which is part of Kingsland's collection. This porcelain piece features blue and white figures and Europeanized Chinese buildings with turrets, suggesting Chinoiserie, a term for the European interpretation and imitation of Asian artistic traditions, especially in the decorative arts. A Union Jack on the tub's bottom indicates that it was purchased in England, probably Staffordshire, an 18th-century manufacturing center for blue decorated porcelain wares. (Both, QHS.)

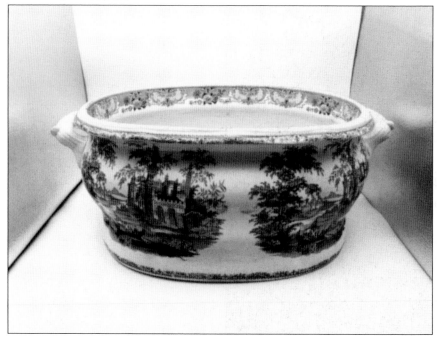

Lewis Latimer (1848–1928) was a true Renaissance man. The African American inventor worked with Alexander Graham Bell on the telephone and Thomas A. Edison on the light bulb. He was also a self-taught master draftsman, patent law expert, poet, painter, and co-founder of the Unitarian Universalist Congregation of Queens. (Not to brag, but he played a few musical instruments, too.) Born the son of fugitive slaves in Massachusetts, he lived the last 26 years of his life in Flushing. His wood-framed, two-and-a-half-story residence with Queen Anne–style architecture remained in the family until 1963. The New York City Parks Department now owns the house, which was built from 1887 to 1889. It is a museum dedicated to promoting African American contributions to technology. Plus, youngsters participate in science-related workshops in its Tinker Lab. (Both, LLHM.)

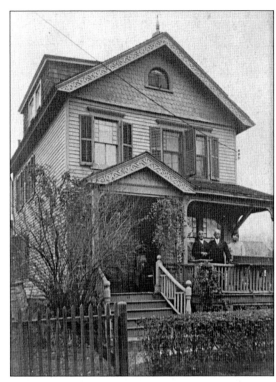

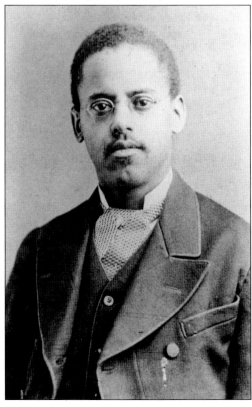

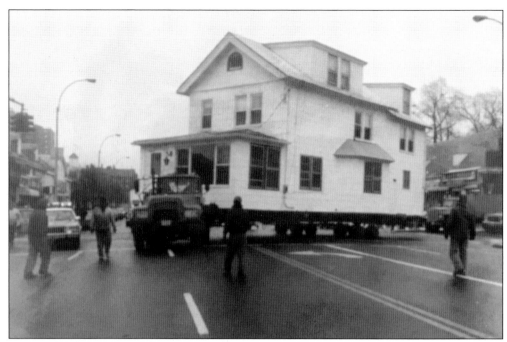

Latimer lived at 137-53 Holly Avenue. Sixty years after he died in 1988, news spread that the dwelling was scheduled for demolition as part of a construction project that would build several new homes on the block. The Committee to Save the Latimer House—which included some of his descendants and the Queens Historical Society—quickly formed to raise money for relocation. With substantial funding from borough president Claire Shulman and Con Edison, the structure was moved about 15 blocks to its current spot at 34-31 137th Street on December 14, 1998. The committee then morphed into the nonprofit Lewis H. Latimer Fund ,which maintains the property. The new spot is next to Latimer Gardens, a four-building public housing project named in his honor. (Both, LLHM.)

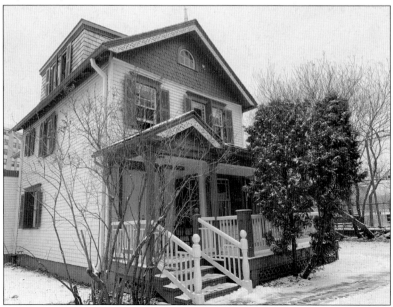

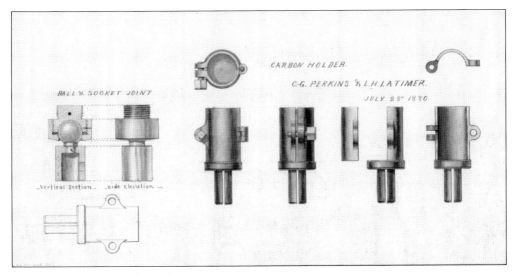

Latimer grew up poor and had to abandon school at age 10 to work odd jobs. At 15, he lied about his age to join the Navy during the Civil War. After an honorable discharge, he got an office job at the Crosby and Gould law firm in Boston, where he taught himself mechanical drawing and drafting, patent law, and electrical engineering. Despite the overt racism of the time, his career took off. In 1880, he got a job at the US Electric Lighting Company, where he oversaw lighting installations in London, Montreal, New York City, and Philadelphia. He then worked for Thomas Edison in 1876 and Alexander Graham Bell around 1885, while inventing the durable carbon filament for electric light bulbs that made them cheaper and longer-lasting. They replaced more dangerous gas lights. (Above, NMAH; below, LLHM.)

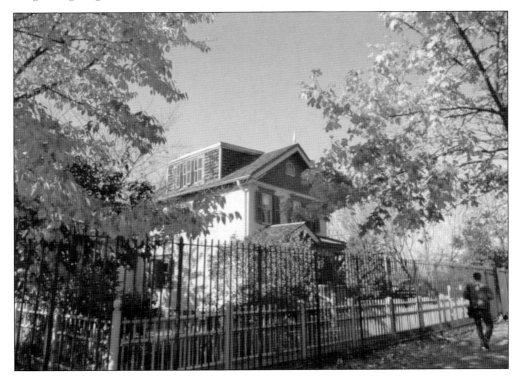

The Pearl-Bullard-Eccles-Kabriski Mansion is the only remaining summer cottage from a construction boom fueled by the super-rich after Flushing's Long Island Railroad station opened in 1839. Located at 147-38 Ash Avenue, the Four-Square Italianate palazzo with wooden clapboard siding and brick-timber walls was erected about 1848. Surrounded by tall trees, it had 14 rooms (including a ballroom), two porches, and three chimneys. The floors were mostly oak, but the dining room floor was pine. It stood among farms and nurseries. True to its name, the first owner was prominent Manhattan lawyer Charles Pearl. After he died, his daughter Agnes sold the five-acre property to Louis Henderong Bullard in 1884. One scion, Roger Harrington Bullard, was an architect who might have added the porches in the 1920s. The next owner, Episcopal reverend George Eccles, divided the plot and relocated the house about 150 feet north, where it could sit on a stone and cement foundation. At some juncture, it became a boarding hotel. In 1954, Mathew Kabrinski purchased the dilapidated house, intending to demolish it. But he fell in love and spent years renovating it. (QTC.)

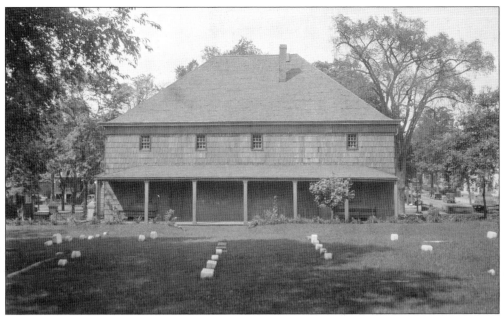

It is easy to overlook from the street. The nondescript, two-story, wooden-frame building is hiding in plain sight amid the hustle, bustle, and neon signs of modern Flushing. But the Friends Meeting House is attention-worthy as the oldest structure in continuous use for religious purposes in New York State and the second oldest Quaker sanctuary in the United States. The structure was built in 1694, mostly by John Bowne. Though the Dutch no longer ruled New York City at the time, their architecture was still popular. This might explain the building's only mildly flamboyant characteristic: a shingled and steep roof. Bowne also donated land for a cemetery in 1676. (He is buried there.) True to their belief in modesty, Quakers did not use headstones until the mid-1820s, and many of the subsequent ones only had carved initials, which have been erased by weather and time. (Both, LOC.)

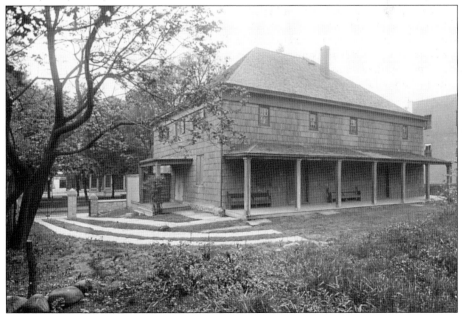

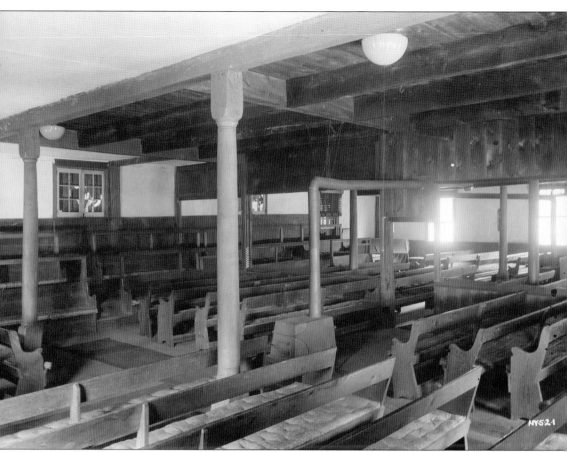

Quaker simplicity is also on display in the sanctuary, where dark floorboards and no-frills benches mix with handmade timber frames and lights designed to look like candles. The front door was intentionally placed in the back—facing the cemetery instead of a busy thoroughfare—due to a long-held belief that parishioners turn inward, away from the world, for spiritual guidance. During the American Revolution, many Flushing residents were Tories who supported King George. Thus, British soldiers used the meeting as a stable, hospital, and storage space. (Services continued throughout the war.) They used the original benches as firewood, but the replacements are still several centuries old. Located at 137-16 Northern Boulevard, the structure was listed in the National Register of Historic Places in 1967, while the chantry became a New York City landmark in 1970. (LOC.)

Three

INDUSTRIAL DEVELOPMENT

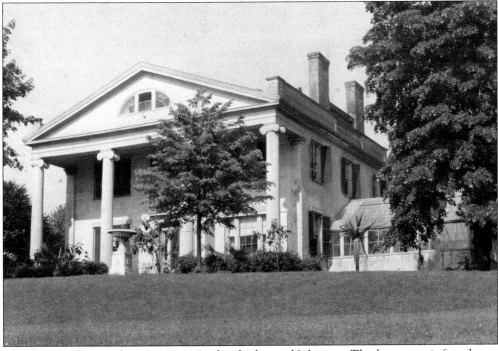

The name is Queens, but "Lawrence" rules the borough's history. The last name is found on a playground, street, triangle, and even two cemeteries today. It is also the moniker of a Long Island town about seven miles east of the county border. The phenomenon dates to William Lawrence, who was born in England in 1623. His first home in the United States was Plymouth Colony, Massachusetts, but he did not like the Puritan lifestyle and ended up in the Flushing area, where he obtained a several-hundred-acre land grant from Gov. William Kieft in 1645. His descendants include various political leaders, bankers, war heroes, and several generations of farmers who owned land around the borough. William's homestead burned down in 1835, but this was a temporary setback for the family, as his great-grandson John Watson Lawrence commissioned the majestic, two-and-a-half-story Willow Bank, seen here in 1846. (JA.)

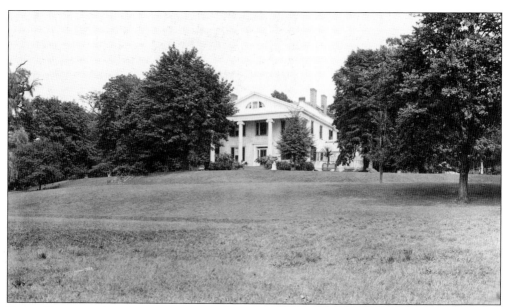

Fronted by a grand staircase entrance with majestic square columns and a large window with the family crest, Willow Bank stood on Lawrence Avenue (now College Point Boulevard) near Lawrence Neck (now College Point, sorry family). Because John, a congressman who was also president of Queens County Savings Bank for 15 years, was passionate about horticulture, the mansion had an attached greenhouse full of palm trees and tropical plants. John's grandson Townsend Lawrence was born in 1871. After growing up in Willow Bank, he became a New York Stock Exchange member who spent most of his time in Manhattan. In 1924, he sold the estate to a developer, who demolished the structure. Factories operated on the site until 1979, when U-Haul purchased the land. Today, U-Haul's building and iconic clock tower stand in its place. (Above, MNY Universal Images Group Art Resource; below, NYMA.)

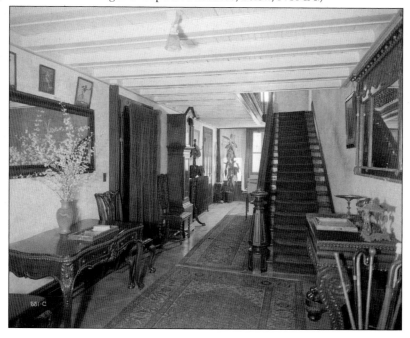

Conrad Poppenhusen (in the 1875 photograph at right) was a de facto benevolent ruler of a corporate town. Born in Hamburg in 1818, he became a whalebone purchaser in Germany, where he married Bertha Marie Henrietta Karker in 1840. A huge fire destroyed large parts of his native city in 1842, forcing the couple to emigrate to Manhattan. At first, he remained in the whalebone business while Bertha gave birth to Adolph, Herman, Marie, and Alfred. In 1852, Poppenhusen obtained a license to use Charles Goodyear's process to vulcanize rubber and started manufacturing everything from caster wheels to brushes in his Manhattan factory, Enterprise Rubber Works. With business booming two years later, he moved his operation to College Point, a mostly rural peninsula in northeastern Queens. His factory workers, most of whom were German immigrants as well, followed him, and College Point became known as "Little Heidelberg." (Both, QPL.)

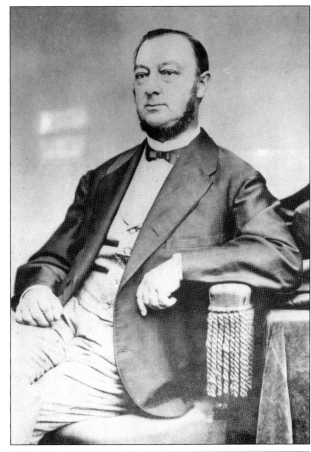

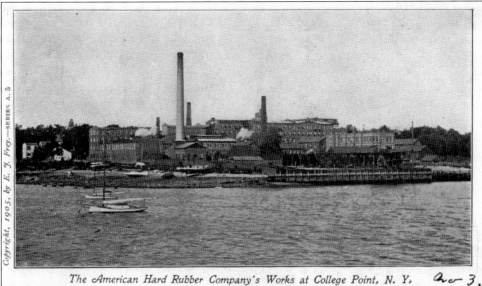

The American Hard Rubber Company's Works at College Point, N. Y.

This works was first owned by Poppenhusen.

Poppenhusen was extremely generous. First, he drained marshes. Then, he paved roads, planted trees, constructed a railroad station, installed sewers, and laid water and gas lines. He donated money for a church and community center, which he endowed. Built in 1868, Poppenhusen Institute housed the first free kindergarten in the United States as well as a vocational high school, courthouse, jail, bank, and library. He also hired local carpenter Joseph Stonebanks to create a villa-style residence with 56 rooms on about six acres on College Point's highest hill, which is now 121st Street at Twelfth Avenue. After retiring in 1871, his sons quickly lost the family fortune, forcing him to declare bankruptcy before his death in 1885. William H. Moffitt Realty Company purchased the property in 1905. The mansion no longer exists, but Poppenhusen Institute is still open, with such programs as karate, music, and art. (Both, QPL.)

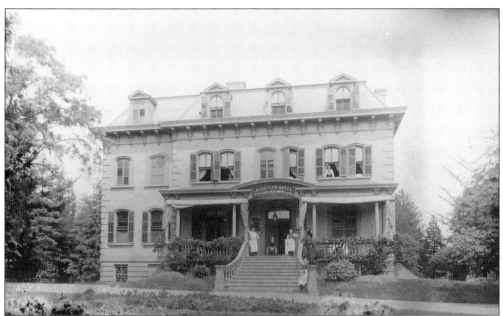

Herman A. Schleicher made a fortune as a wholesaler. In 1856, he bought 14 acres in College Point that had views of Long Island Sound as well as orchards, gardens, and a pond. Joseph Stonebanks, who built Poppenhusen's mansion, constructed a two-and-a-half-story redbrick residence with Italianate and French Second Empire architecture at 11-41 123rd Street. It had a Mansard roof, arch windows, paired columns, and a continuous cornice. Herman died in 1866, and his wife, Malvina, sold the property in 1870. John Jockers converted it into Grand View Hotel, a popular resort with grass tennis courts. However, Jockers slowly sold many of the acres to developers. The house received New York City landmark status in 2009 after a battle between local historians and the owner, Robert Cunniffee, who opposed the designation. In the c. 1893 photograph at right, a Mr. Johnston poses with a rifle with the hotel in the background. His slouch hat has an insignia badge of crossed rifles with the letter "D" below the barrels. (Both, QPL.)

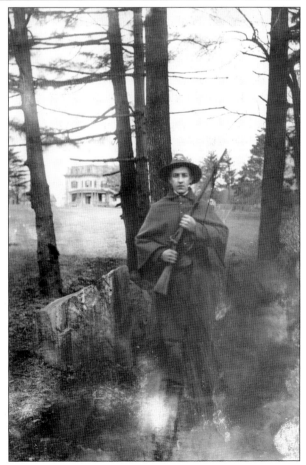

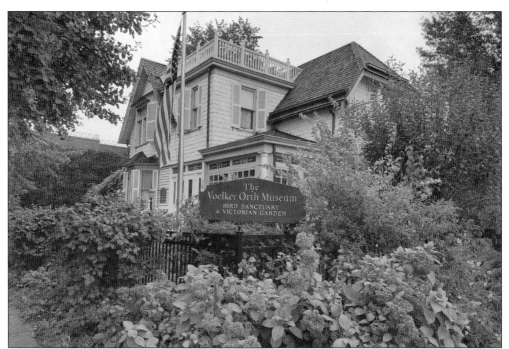

Though located in what is now the predominantly Korean area of Murray Hill, the Voelker-Orth Museum offers a genuine view of 20th-century life among Germans and German Americans. Conrad Voelcker (note the different spelling) moved to the United States from Edenkoben in the Rhineland at age 19 and founded a German-language newspaper, *Der Pfälzer in Amerika*, in 1884. The newspaper folded in 1917 due to anti-German feeling during World War I, but Conrad and his brothers had already expanded it into a successful printing business. Conrad married Elizabeth Maibach, whose German immigrant father was a butcher, and they had a daughter, Theresa, in 1899. Conrad and Theresa were extremely passionate about horticulture. Today, their two-and-a-half-story house, which was built in 1891, is distinguished by its Victorian garden, which contains popular plants and berry bushes from the late 19th century. (Above, QTC; below, VOM.)

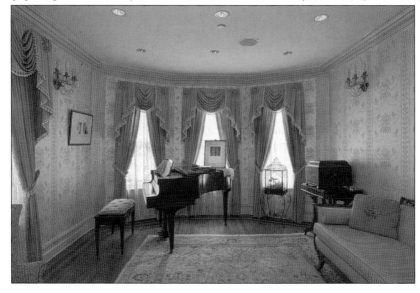

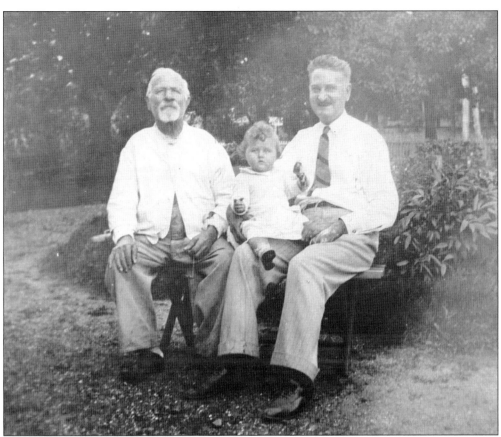

Theresa married Rudolph Orth, a first-generation German immigrant who worked as a surgeon with the New York Police Department, and gave birth to Elisabetha Orth in 1926. The Orths then adopted a nine-year-old girl, Barbara, in 1935. In addition to being mother and daughter, Theresa and Elisabetha were best friends who lived in the house after Rudolph's death in 1948. Theresa died in 1992, and Elisabetha lost her life after a car accident three years later. Elisabetha bequeathed her grandfather's newspapers to an archive in Germany and converted the Murray Hill estate, which is located at 149-19 Thirty-Eighth Avenue, into a nonprofit educational resource. Even though she never married, she established that the venue could be used for weddings, as the relic dress in the photograph to the right indicates. (Both, VOM.)

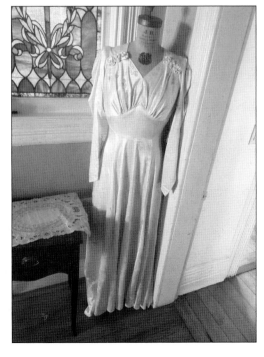

Murray Hill was transforming from rural to suburban when the house was built, and many of its furnishings represent middle-class values and tastes that were in vogue at the turn of the 19th century. (Plus, nobody lived on the premises after the Voelkers and Orths, so everything is authentic.) As seen in this photograph, stained glass is everywhere, as it was a hot item and status symbol. A Victrola record player, 1930 Sohmer piano, and Wardian plant cases are on site. An archived 1909 bill informs that the Department of Water Supply, Gas and Electricity installed 23 outlets and 36 lights for Conrad Voelker. The property received New York City landmark status in 2007. (VOM.)

Four

OLD WEALTH, NEW WORLD

Bayside went through its first real estate boom after railroad service was extended to the northeastern Queens hamlet in 1866. Robert M. Bell, an active member of the Queens County Agricultural Society, rode the wave in 1873 by constructing a three-story dwelling for his daughter Lydia Ann and her husband, John William Ahles, a grain merchant and member of the New York Product Exchange's board of governors. Located on land that Robert had purchased from the Lawrence family (see chapter three), it was pure Second Empire, an eclectic style based on French Renaissance and Baroque models. Cubic in form, it included a dormered Mansard roof, molded cornice, and hexagonal slate shingles. In 1924, the house was relocated to 39-24 and 39-26 213th Street to allow for a cut-through. Soon after, architect Lewis Edgar Walsh removed the wrap-around porches and two-story bay window, replaced the clapboards with stucco, and installed paneled doors and multi-pane windows. He added a sleeping porch in the popular Arts and Crafts–infused Colonial Revival style, converted a carriage house into a garage, and reconfigured the fenestration on the second story of the pavilion on the west façade, where he added a long horizontal opening with four pairs of multi-light casements. Five other owners lived there before Robert Rubin bought the property in 2007. The New York City Landmarks Preservation Commission granted landmark status to what it called the John William and Lydia Ann Bell Ahles House in 2016, noting that it was a unique representative of Bayside's farm-to-suburbs history. It is the area's only remaining Second Empire structure. (QTC.)

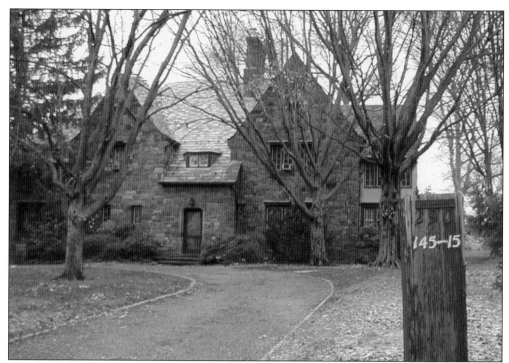

Charles and Florence Fitzgerald commissioned French-trained architect John Oakman to design their Bayside dream house on a 200-by-100-foot plot adjacent to the Old Country Club in 1924. Set back from the property line at 145-15 Bayside Avenue, the Stockbroker Tudor style was very popular among the wealthy in the 1920s, a decade of optimism and affluence. The house features two chimneys, fieldstone walls, a multi-colored slate roof, and leaded glass windows. The Fitzgeralds sold to Ethel and Morris Ginsberg, whose family lived there for more than 70 years. Despite receiving New York City landmark status in 2005, the Assembly of God Jesus Grace Church made some renovations, installed a fence, and chopped down trees that were older than the house after buying the property in about 2007. The fence was removed as per government orders. (Above, Matthew A. Postal, NYC LPC; below, QPL.)

(Shore Acres) Residence of G. H. Leavitt, Bayside, L. I.

No entity had more impact on the borough's rural-to-urban conversion than Cord Meyer Company. In 1893, German immigrant Cordt Meyer purchased land from Samuel Lord of Lord & Taylor in the farming community of Newtown. He formed a partnership with his brothers Christian and John, and did basic development work, such as mapping streets, and constructed houses. They planted elm trees and renamed the community Elmhurst. In the early 1900s, the brothers moved east, buying land in Whitepot from the original farming families. They built residential dwellings and changed the area's name to Forest Hills. They also amassed a fortune, and in 1904, the Meyers purchased a 225-acre farm in Bayside, where they built a three-story wooden clapboard mansion. The Meyers sold the property in the 1950s, and the mansion was demolished in 1963. Much of the land is now the Bay Terrace Shopping Center, which Cord Meyer Development manages. (GAHS.)

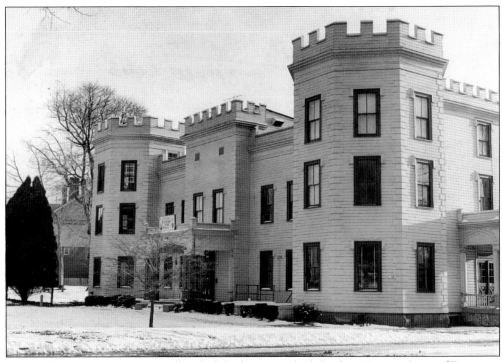

It was called the Officers' Mess Hall and Club when it was built for the US Army Corps of Engineers in 1887, but nowadays, everybody refers to it as "the Castle." The Gothic Revival castellated structure is at 208 Totten Avenue inside Fort Totten Park at the borough's northeastern tip. The three-story, wood-frame mansion features an uncommon U-shaped layout with a central entrance between octagonal corner pavilions. It became a New York City landmark in 1974 and was listed in the National Register of Historic Places in 1986. The Castle is currently the headquarters of the Bayside Historical Society, which maintains the property and hosts exhibitions and lectures there. The map below is from 1909. (Above, BHS; below, NYPL.)

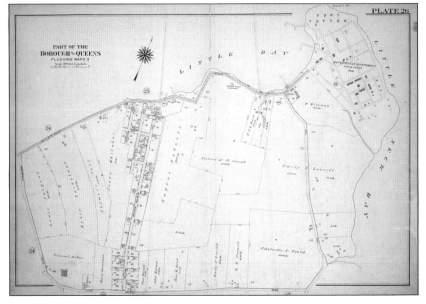

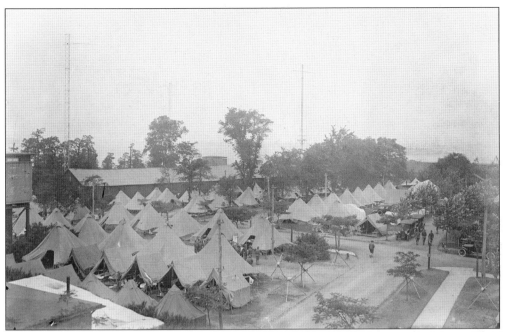

Completed in 1862, Fort Totten first served as a barracks, prison, and armory for Union forces during the Civil War. In 1867, the roughly 13-acre Parade Grounds was established on-site. As was common on military bases around the United States, the area was used for muster, where troops would assemble in front of their commanders for inspection and roll call. (The phrase "to pass muster" is still part of the modern-day vocabulary.) The New York City government completed a huge renovation of the entire complex in 2005, turning Fort Totten into a 49.5-acre public park. A baseball diamond, octagonal gazebo, public swimming pool, and soccer fields are now on the old Parade Grounds, but the Castle remains. These images are from 1917 or 1918. (Both, LOC.)

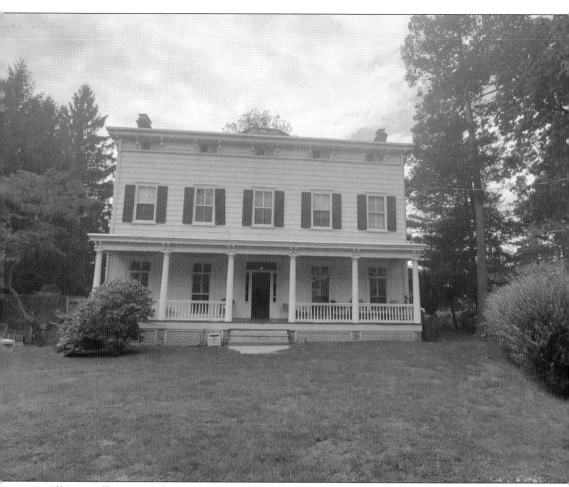

Allen-Beville is a Greek Revival mansion with a Doric-columned front porch, octagonal cupola, and center entrance door. The front windows have four-over-four panes, capped by eared moldings and flanked by shutters. With views of Long Island Sound, the house lies at 29 Center Drive on a plot with a carriage path. Throughout the 18th and 19th centuries, the Allen family lived and farmed there. Benjamin P. Allen bought the property on August 11, 1847, and constructed the house over four years. His wife, Catherine, and he raised seven children there. As the 19th century progressed, the wealthy Douglas family bought the surrounding land, a nearby mansion, and Allen-Beville to use as a guesthouse. Then in the early 1900s, the Douglas Manor Company started dividing up the Douglas estate to create a suburb. It saved this house, which had two other owners before Hugh and Eleanor Beville bought it in 1946. (QTC.)

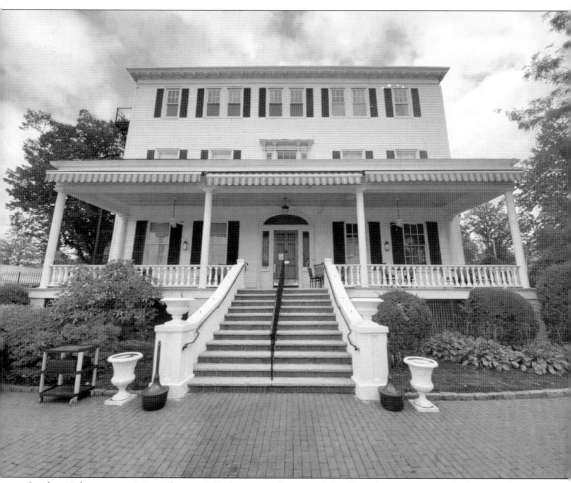

In the 18th century, Maj. Thomas Wickes owned most of the Douglaston peninsula (or Douglas Manor). In the early 1800s, he sold his land to Wynant Van Zandt, who built a three-story Greek Revival mansion with an elaborate cornice, Tuscan-columned porch, and elliptical fanlight over the entrance in 1819. In 1862, George Douglas added it to his sprawling estate with the name Douglas Manor House. (His son William P. Douglas became world-famous when his yacht, *Sappho*, won what is now the America's Cup in 1871.) In 1906, the Douglas family sold the estate to the Douglas Manor Company, and much of the land was divided into individual residences with homes by the Rickert-Finlay real estate company. The Douglaston Club purchased the building in 1921. Located at 600 West Drive, it is a clubhouse today, sitting amid tennis courts and a pool. (QTC.)

Cornelius Van Wyck, whose grandfather had emigrated from Holland in 1660, inherited 125 acres on Douglas Manor that his father, Johannes, had purchased from the Cornell family (see chapter five). Cornelius built a Dutch Colonial house with oak beams, hand-hewn shingles, and a saltbox-type roof on a hill with a direct view of Little Neck Bay in 1735. His son Stephen, a delegate in the Continental Congress, then expanded the footprint over the following 35 years. (Both, JA.)

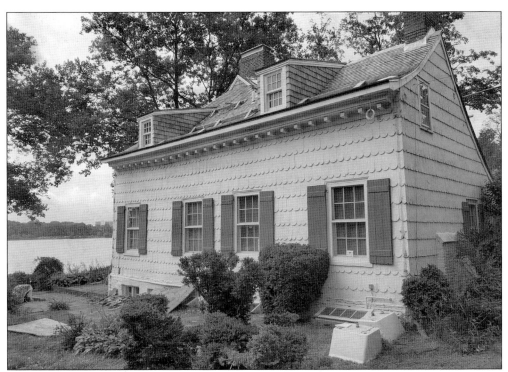

Despite a kitchen addition in 1930, the inside remains basically the same as it was in the 19th century. The living room is still adorned with Georgian mantelpieces, and the studio has a fully paneled fireplace wall with a classic box cornice. The Cornelius Van Wyck House achieved New York City landmark status in 1966 and was listed in the National Register of Historic Places in 1983. Located at 126 West Drive, it is about five miles from the Van Wyck Expressway (Interstate 678), which cuts through the borough's mid-section, running from the Whitestone Bridge to John F. Kennedy International Airport. (Above, QTC; below, NYSA.)

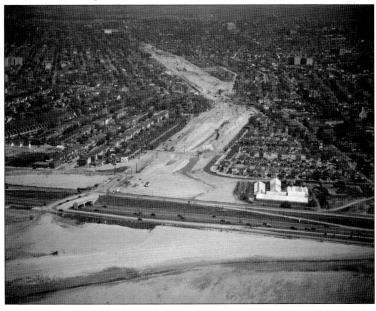

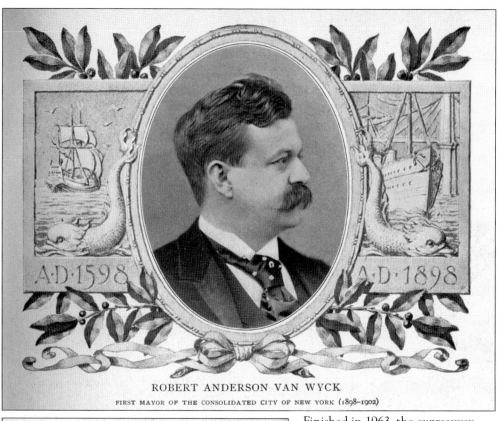

ROBERT ANDERSON VAN WYCK

FIRST MAYOR OF THE CONSOLIDATED CITY OF NEW YORK (1898–1902)

Finished in 1963, the expressway is named after a descendant, Robert Anderson Van Wyck, who was the first mayor of New York City after the five boroughs consolidated in 1898. Although his tenure was marred by the Great Ice Scandal of 1900, Mayor Van Wyck led some major transportation projects, such as creating the first subway system. Thus, the expressway was named in his honor by Robert Moses, the prolific urban planner behind the Grand Central Parkway, Jones Beach, the Brooklyn-Battery Tunnel (now the Hugh L. Carey Tunnel), and many other public works projects. (Above, NYPL; left, NYSA.)

Five

HORSES AND
ALL THAT JAZZ

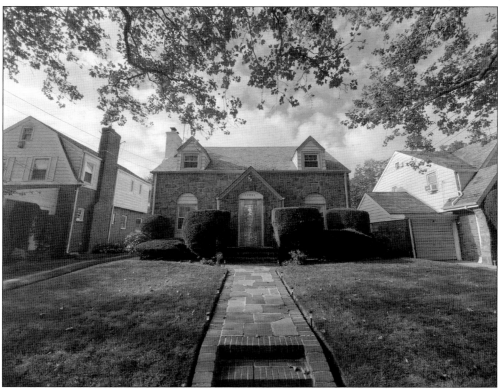

It was home base for Jackie Robinson. James Brown was on the scene. Count Basie took the plunge, while W.E.B. Dubois started a family there. Plus, Ella Fitzgerald bought this house at 179-07 Murdock Avenue in 1949. Addisleigh Park is a small portion of St. Albans that was once called "Black Hollywood East" because so many prominent African Americans lived there. The rural Southeastern Queens area first started attracting developers after 1898, when a Long Island Rail Road station was built in St. Albans. The Queensborough Bridge's opening in 1904 created more interest, as did the construction of the St. Albans Golf and Country Club in 1915. The streets were mapped but not paved in 1918. The biggest boom took place in the 1920s and 1930s, when developers filled the wide thoroughfares with eclectic, single-family homes in the popular revival styles of the time, including Arts and Crafts, English Tudor, Mediterranean, Neo-Colonial, Neo-Classical, and Prairie. Most houses were three stories high with a mixture of brick, stone, stucco, and wood, and were set on large lots as per the Garden City movement. (QTC.)

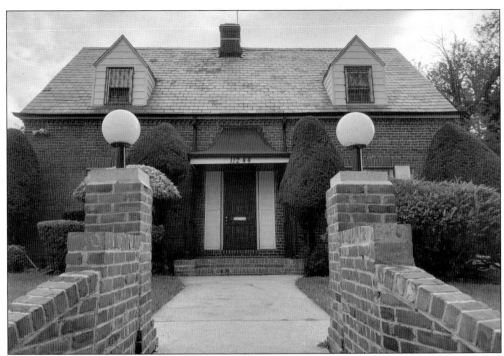

In the early 20th century, covenants prohibited white homeowners from selling to non-whites, but quiet transactions took place anyway. The secrecy ended in 1946, when William "Count" Basie, the world-famous jazz bandleader, purchased a home at 174-27 Adelaide Road. (His pool parties were legendary.) Lena Horne followed the same year. Jean Baptiste "Illinois" Jacquet purchased the above property at 112-44 179th Street in 1950. Trumpeter/composer Charles "Cootie" Williams sold his three-story Tudor-style house at 175-19 Linden Boulevard (below) to James Brown in the 1960s. To maintain privacy, "the Godfather of Soul" erected a high fence with the monograms "JB" in certain places. He also installed a moat and drawbridge that are no longer there. (Both, QTC.)

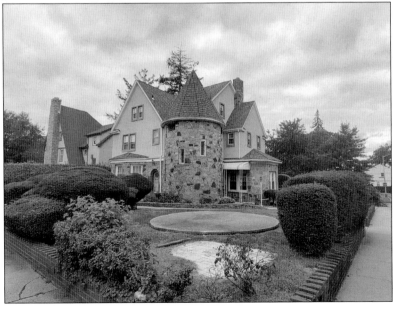

Jackie Robinson's residence at 112-40 177th Street is pictured here. The family lived there through 1955, when the Brooklyn Dodgers (finally) won a World Series. Partly to get some privacy from the constant gawkers, they moved to Connecticut. (QTC.)

It is believed that jazz pianist Thomas "Fats" Waller was the first African American to buy property here in the 1930s. Located at 173-19 Sayres Avenue, his house, seen here, features a commemorative plaque, and is still a frequent stop for tourists. Other Addisleigh Park A-listers include boxing champ Joe Louis, civil rights leader Percy Ellis Sutton, and Milt "the Judge" Hinton, whose home had a built-in Hammond organ and a Steinway grand piano. (QTC.)

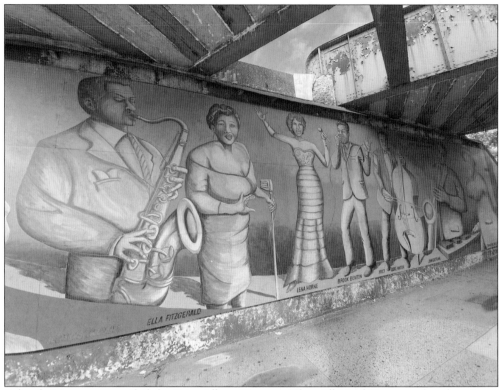

A local civic group unveiled the *Saint Albans Greatest: They All Lived Here* mural under a Long Island Railroad trestle on Linden Boulevard in 1983. Painted by Joe Stephenson, it displays previously mentioned local musical legends as well as Billie Holiday, Lena Horne, John Coltrane, and Brook Benton. (QTC.)

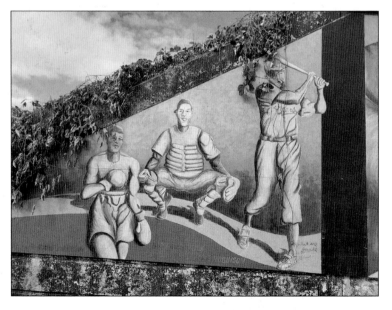

Another section of the mural depicts famous athletes such Jackie Robinson, his Dodgers teammate Roy Campanella, and Tommy "Hurricane" Jackson, a boxer. The district obtained New York City landmark status in 2011, mostly because of its notable history of breaking racial exclusivity followed by prominence. (QTC.)

After Dutch immigrant Elbert Adriance bought land in eastern Queens in 1697, five generations of descendants lived and farmed it. In 1772, Elbert's grandson Jacob built a three-room house for himself and his wife, Catherine. The timber-frame structure has a Dutch Colonial style with wattle-and-daub insulation, plank floors, and tulip poplar–beam floorboards. In the beginning, it had a roof eave, which probably protected a masonry wall from cascading rain and snow. Later owners enlarged the footprint with such additions as a double-pitched roof with high gables at each end, a wood-columned porch, fascia-type low windows set just below the eave, and a 12-over-12 window sash. The property is seen in 1927 above. In 1986, the site (below) was restored to represent an 18th-century Dutch-American farmhouse. The interior reflects Dutch Colonial, Greek Revival, and Victorian styles. (Both, QCFM.)

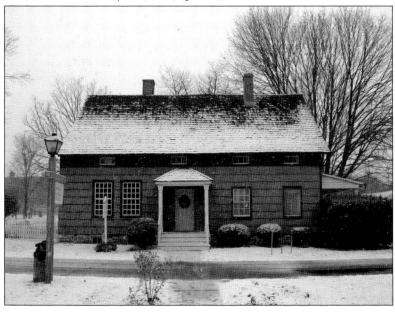

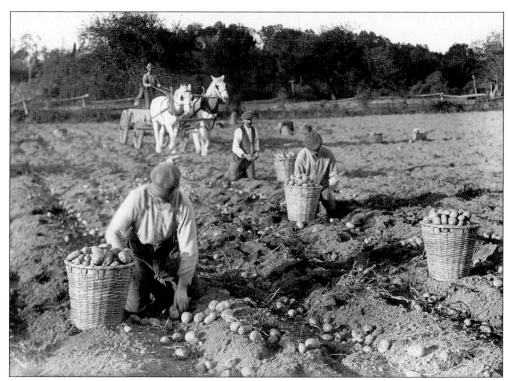

Starting in the early 19th century, the farm evolved into a market garden, or truck farm. The term came from the French word *troquer*, which means "to barter," as the internal combustion engine was still decades from being invented. These new homesteads grew cash crops to sell and for personal consumption. This era was also when the Adriances relinquished ownership, which passed through a succession of farmers before real estate investor Pauline Reisman bought a portion and flipped it to New York State for use by Creedmoor Psychiatric Center in 1926. For a long time, it was erroneously referred to as the Thomas Cornell Farmhouse after an English immigrant who settled in the area in about 1665. However, Cornell lived further up the road. (Both, NYSA.)

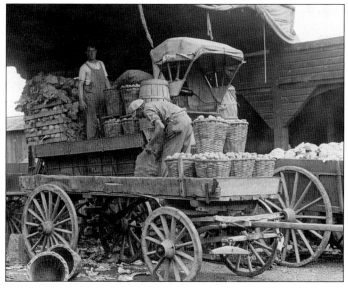

As therapy, Creedmoor (seen here around 1933) patients worked the land for food and ornamental plants, while staffers used the house as an office. In the mid-1970s, the Colonial Farmhouse Restoration Society of Bellerose obtained a permit to occupy what is currently called the Adriance Farmhouse, and the Queens County Farm Museum was born. Ownership went to the New York City Parks Department, but Creedmore still operates nearby at 80-45 Winchester Boulevard. (LOC.)

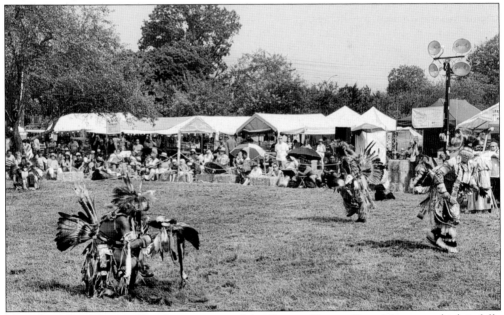

Nowadays, the Adriance Farmhouse is part of the Queens County Farm Museum, which is fully operational with livestock, planting fields, heavy machinery, an apple orchard, a greenhouse, and an herb garden. In addition to producing thousands of pounds of vegetables, flowers, eggs, and wildflower honey every year, the property hosts special events, such as an antique motorcycle show, carnivals, fairs, Native American powwows (pictured), and sheep-shearing festivals. (QTC.)

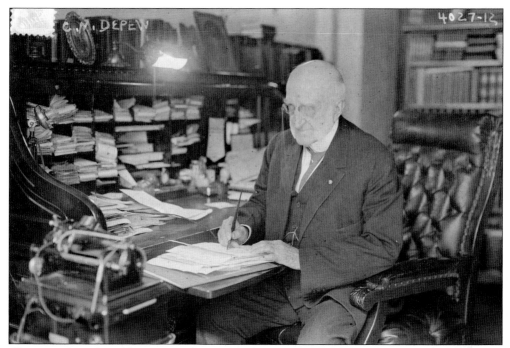

Chauncey Depew, seen here in 1912, was Cornelius Vanderbilt's personal lawyer, president of the New York Central Railroad System, and a senator. He was also New York's secretary of state when Pres. Abraham Lincoln was assassinated in 1865. Thus, he escorted Lincoln's body through the Empire State on its way to internment in Springfield, Illinois. (LOC.)

Depew (1834–1928) must have felt a mix of emotions at the time, as he mourned a man whom he admired greatly and even imitated. In 1913, he commissioned architecture firm Mann and MacNeille to construct a replica of President Lincoln's wood-frame Springfield home for his summer cottage (pictured) on Midland Parkway in Jamaica Estates. (QTC.)

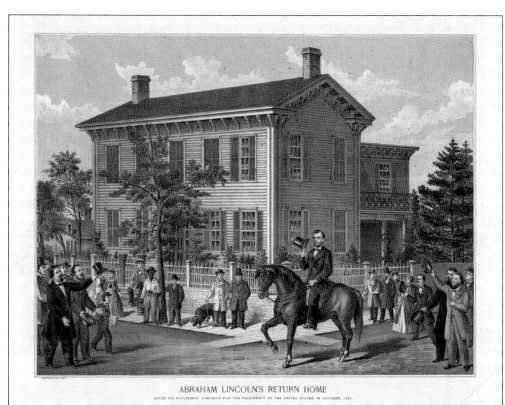

ABRAHAM LINCOLN'S RETURN HOME
AFTER HIS SUCCESSFUL CAMPAIGN FOR THE PRESIDENCY OF THE UNITED STATES, IN OCTOBER, 1860.

It was a secret for many years. After Depew died of pneumonia in 1928, ownership changed, and the story behind its model was forgotten until 2009, when seventh-graders at nearby Immaculate Conception Catholic Academy found a newspaper article dated August 24, 1919, with an architectural drawing of Depew's house. They visited the venue, which lies near the Grand Central Service Road, and discovered that the photographs matched the actual building. With a little more research, they confirmed that it was a complete copy, only in brick. (Both, LOC.)

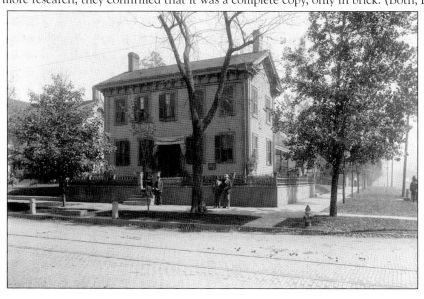

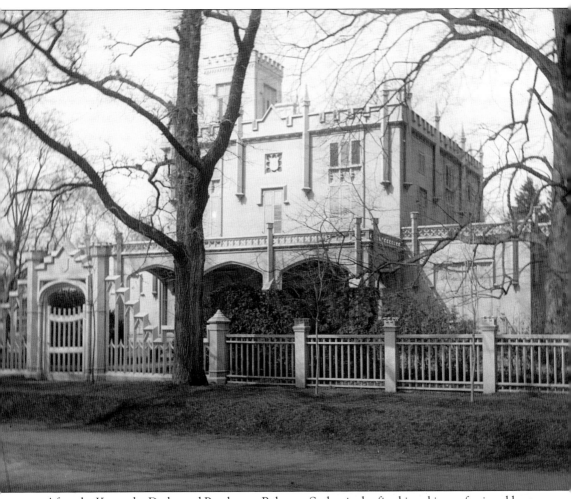

After the Kentucky Derby and Preakness, Belmont Stakes is the final jewel in professional horse racing's Triple Crown. The competition takes place in Belmont Park every June. About a third of the border-straddling hippodrome is in Queens Village, with the rest in Elmont, Long Island. The racetrack dates to the early 1900s, when a group headed by August Belmont II purchased property from the wealthy Manice family. Spread out over about 100 acres, the estate had a gray, turreted Tudor-Gothic mansion called Oatlands that faced present-day Hempstead Turnpike. The builder, architect, and construction date are unknown, but William DeForest Manice probably built it around 1820. Getting back to Belmont Park, the developers built the racetrack on the side and converted Oatlands into the Turf and Field Club, which operated until 1956, when it was demolished to make way for a bigger complex. (QPL.)

Six

HIDDEN TREASURES

David Selig and Cecilia Dean call it "the Castle," and they rent out this 5,000-square-foot Rockaway mansion for photograph sessions, art exhibitions, and wellness events—even though they live there. Newly added amenities include a Finnish sauna, steam room, and yoga studio, and a driveway with space for four cars. With the modern touches, it fulfills Selig's longtime dream of combining community use with living quarters, but the three-story structure is actually a centuries-old palazzo that Frank Busto shipped in pieces to Rockaway from Tuscany in 1912. The Italian immigrant placed it a few yards from Jamaica Bay at 403 Beach 117th Street to take advantage of 360-degree views and refreshing summer breezes. Busto owned a popular restaurant near Wall Street in Manhattan, and owning the waterfront villa was his dream come true. As time passed, he filled the rooms with marble, stones, and stained glass from Italy and balloon shades, crystal chandeliers, and plenty of varnished wood. Busto's children did not want to live in Rockaway, though, so after a few ownership changes, Selig and Dean were able to buy the house and tailor it to their dreams. (QTC.)

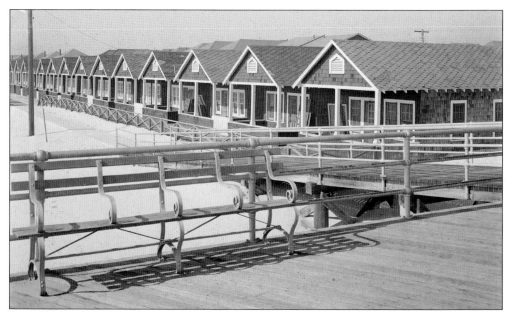

On the other end of the five-and-a-half-mile peninsula, the Far Rockaway Beach Bungalow Historic District stretches from Beach Twenty-Fourth Street to Beach Twenty-Sixth Street between Seagirt Avenue and the boardwalk/Atlantic Ocean. Almost six acres, the strip contains approximately 100 bungalows, and has been listed in the National Register of Historic Places since 2013. (NYMA.)

In most cases, the one-and-a-half-story, wood-frame houses are basically identical, with three bedrooms, a small kitchen, a bathroom, and a porch on a 25-by-50-foot lot. Six-foot common alleyways separate each dwelling. They have side-hall entrances, two double-hung windows, and dormers, while the roofs are hipped, gable, and clipped gable. The porches have wainscot or stucco ceilings, wood or battered stucco columns, and wood or concrete stoops. (NPS.)

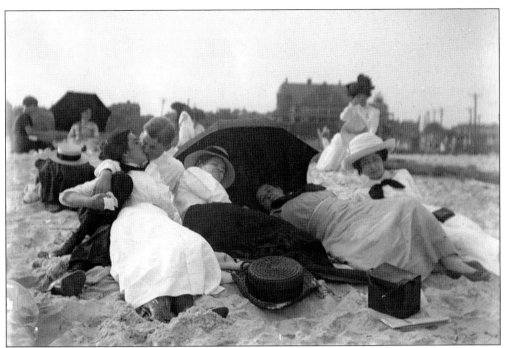

The area's heyday began in the early 1900s. Henry Hohauser, an architect who became famous for his Art Deco work in Miami, and Isaac Zaret, the main builder, created more than 1,000 bungalows between 1921 and 1925. During this boom, summer communities sprung up near beaches around the tri-state area. In Far Rockaway, the blocks were generally segregated, with distinct Jewish, Irish, and Italian areas. The image above was captured in 1905, and the photograph below is from 1900. (Above, QPL; below, LOC.)

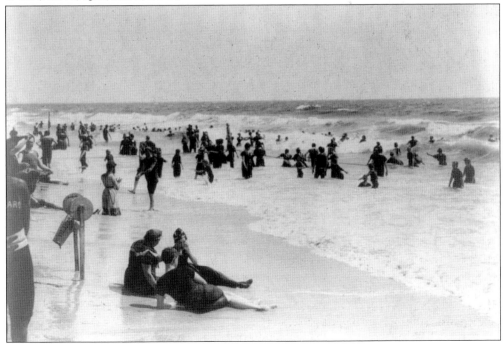

During World War II, fewer people spent their summers in Far Rockaway. Then, in 1950, a fire destroyed the local railroad trestle at a time when many New York City families were buying cars and traveling farther to Long Island beaches for recreation, thanks to the booming economy and new highways created by Robert Moses, the famous urban planner mentioned in the section on the Van Wyck Expressway. Over the following decades, many owners sold their bungalows, while others were demolished and replaced with apartment complexes. A soaring crime rate in the 1980s led to more flight, and a series of extreme storms, especially Hurricane Sandy in 2012, caused more destruction. People still live there today, although there are many abandoned and dilapidated bungalows. (NPS.)

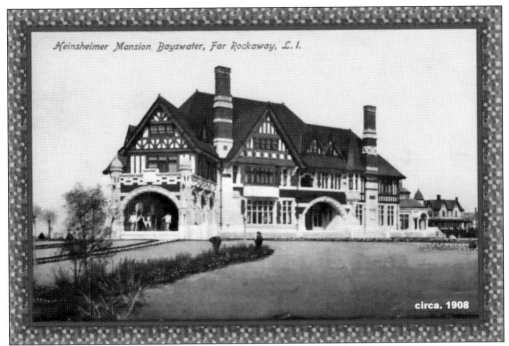

Heinsheimer Mansion. Bayswater, Far Rockaway, L. I.

circa. 1908

Bayswater is a residential enclave jutting out from the eastern end of Rockaway into Jamaica Bay. Starting in 1878, William Trist Bailey developed it as a planned community on land purchased from Richard Cornell's descendants. Rockaway was a summer community for Manhattan's rich—similar to the Hamptons today—with large Victorian homes, railroad access, and a yacht club. In 1907, Louis A. Heinsheimer, a Wall Street tycoon with Kuhn, Loeb & Company, purchased a large estate, demolished a mansion, and built a two-and-a-half-story granite-and-marble residence that mixed Tudor and English styles (above postcard, 1908). Designed by Mexican architect Rodolphe Daus, it was 175 feet long and intentionally over-the-top with gargoyles and heavy woodwork, carved moldings, and Guastavino tiles on the inside, along with 13 servants, according to the Census. Serpentine paths, manicured flower beds, and a conservatory adorned the land. (Both, MCNY.)

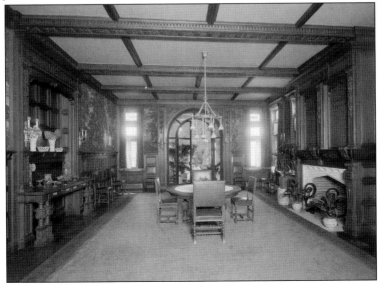

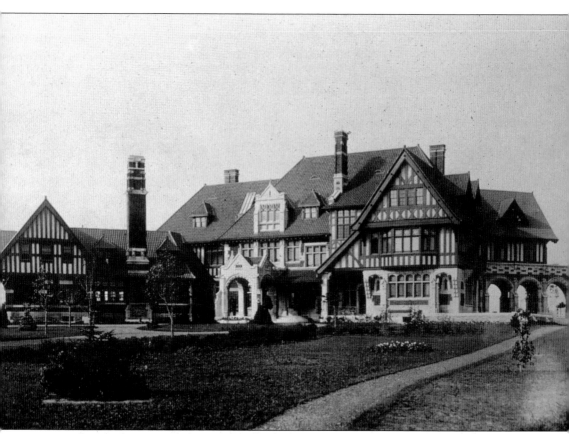

It was pure luxury, but Heinsheimer did not get to enjoy it much. He died after an appendicitis operation in 1909. He was single, so his younger brother Alfred inherited it. In 1925, Alfred donated everything to the Hospital for Joint Diseases, along with a $500,000 endowment for future expenses. The facility served as a group home for disabled youth, and later a private special education school and even a yeshiva before hitting the market in the mid-1980s. The Trust for Public Land purchased the site and turned it into what is now the 12-acre Bayswater Point State Park. (NYU Langone Hospital for Joint Disease.)

Seven

DREAM HOUSES AND NIGHTMARES

George Washington slept here—and was lucky he woke up alive. On April 20, 1790, the war hero had just been sworn in as president of the brand-new United States. According to his diary, he stayed at a "pretty good and decent house" with eight rooms, wrap-around porch, tavern, and tea garden in Jamaica while traveling across Long Island to thank his spies and soldiers. The same entry describes the soil: "sandy and appears to have less strength, but is still good and productive." The hotel, called Queens' Head Inn at the time, was established by Thomas Rochford in 1781. By the time President Washington got there, it featured a victory pole installed during a raucous Revolutionary War celebration on December 8, 1783. Plus, ownership had changed to Edward Bardin, a blessing for the commander-in-chief, as Rochford was a Loyalist. (CB.)

Always busy, the hotel was the starting point for trotting races, hare-and-hound hunts, bicycle marathons, and the first major automobile competition on Long Island, the 100-Mile Auto Endurance Race of 1901. (Brooklyn and Queens are geographically part of Long Island.) The inn also hosted meetings and rallies before and during the Civil War, and planning sessions for the incorporation of Queens into New York City and the contemporaneous creation of Nassau County in 1898. The building was razed in 1906. (Above, CB; below, Howard Kroplick.)

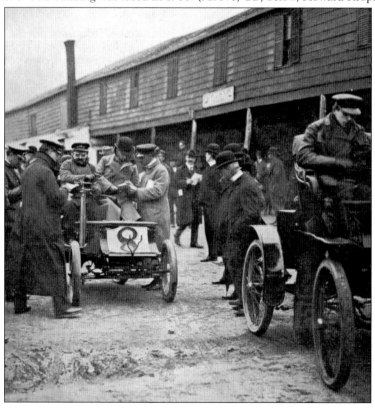

Born to Dutch immigrants in 1732, Rev. Abraham Keteltas purchased a mansion in Jamaica in 1760. He got involved in politics as a member of the Provincial Congresses and the convention of 1777, which framed the New York State constitution. He gave fiery pro-Revolution speeches in Dutch, French, and English. In one, he said he would rather "shoulder his musket than pay the tax on tea." (QPL.)

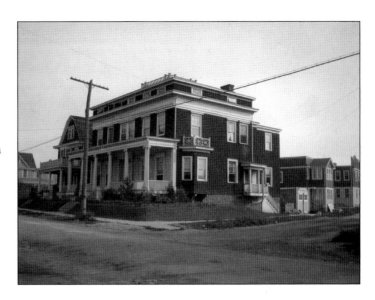

Reverend Keteltas was in trouble when the British occupied Long Island in 1776. He fled to Connecticut, abandoning his family, slaves, and livestock, while soldiers occupied his house, stole his possessions, and cut down 100 acres of woods. The restored mansion was moved to where it still stands at 88-35 and 88-37 144th Street. The 1922 photograph at the top of this page shows the shingled house with white trim, Ionic porch columns, and a widow's walk. This photograph shows it today. (CB.)

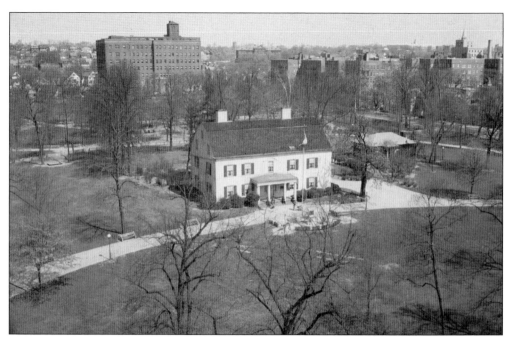

From 1805 to 1896, Rufus King and his descendants lived in King Manor, a three-story, three-chimney mansion with clapboard windows that was built in 1730 with an addition constructed in the early 1800s. The King family raised livestock and grew apples, barley, corn, peaches, potatoes, strawberries, and wheat on about 150 acres. They were ardent abolitionists who paid their African American workers wages even though slavery was permitted in New York State until 1827. (Other workers were immigrants from Scotland and Ireland.) Listed in the National Register of Historic Places since 1974, it is currently the second-longest-running historic house museum in New York City. It is also the main attraction in Rufus King Park, an 11-acre New York City Parks Department property in Downtown Jamaica. The above image is from 1946, and the photograph below is from 1914. (Above, NYMA; below, KMA.)

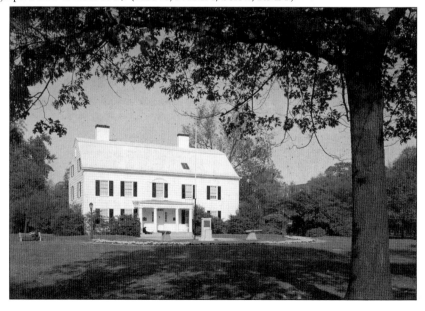

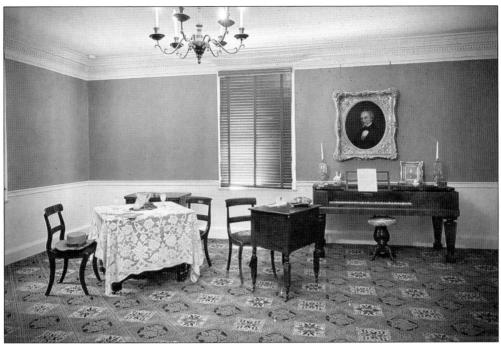

Due to the mores of the time, very few visitors to King Manor ventured past the downstairs parlor in the 18th and 19th centuries. Plus, children were basically banned from this formal space. As to be expected, the family made sure this room always looked great. In a subdued attempt to keep up with the Joneses, King replaced the original wooden fireplace surround with Italian imported marble that is still there today. He wanted to live in a gentleman's estate, and was proud of the wide center hall, sweeping stairs, and Georgian and Federal details. At other times, the servants performed such functions as cleaning candlesticks, ironing, and spinning here. (Both, KMA.)

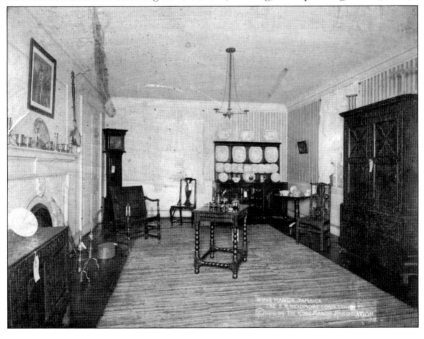

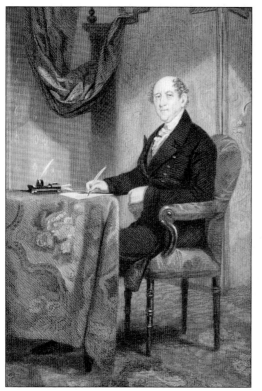

Rufus King (1755–1827) was the youngest signer of the US Constitution, a senator for almost 18 years, and ambassador to Great Britain. Though he did not win, he was twice selected as the Federalist candidate for vice president and once for president. Overachievement was in his DNA. His sons included John, who served as an assemblyman, congressman, and governor; Charles, who edited the *New York Enquirer* before becoming president of Columbia College; Edward, who founded Cincinnati Law School; James, a War of 1812 veteran who became a New Jersey congressman; and Frederick, a doctor whose anatomy lectures were legendary. Rufus married Mary Alsop, the only child of Mary Frogat and John Alsop, a wealthy merchant and member of the Continental Congress, in 1786. She was one of the era's most respected New York City socialites. (Left, Universal Images Group Art Resource; below, NYPL.)

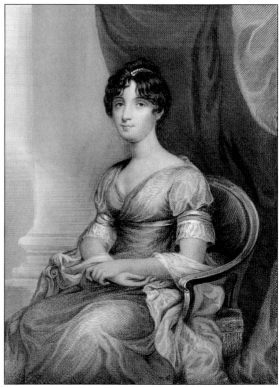

One of the scions, Lt. Rufus King, won a Medal of Honor for his service with the New York Militia that fought in the Battle of Antietam in 1862. The infamous Maryland battle, which included the bloodiest day in the history of American warfare, was a turning point in the Civil War that led to the North's victory. In 1869, Lieutenant King was promoted to captain before honorably mustering out in January 1871. He is seated at left in the 1862 photograph above, with Lt. Alonzo Cushing, Lt. Evan Thomas, and three artillery officers. (Above, LOC; below, King Manor Association.)

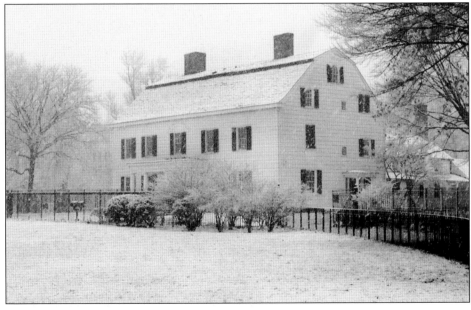

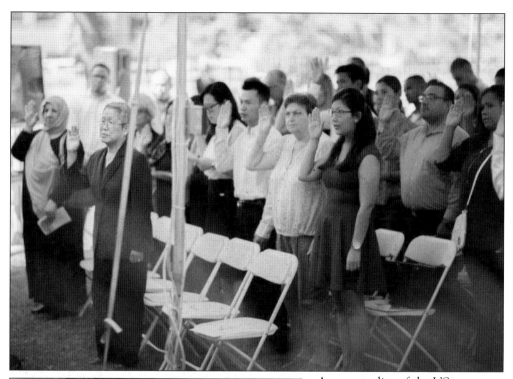

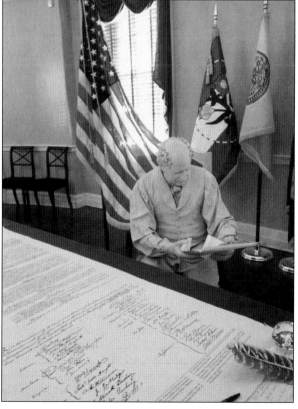

A stone replica of the US Constitution is on permanent display next to a stone statue of Rufus King at King Manor Museum. The venue also hosts the annual naturalization ceremony on September 17, which is Constitution Day. It is the final step in the process, and the immigrants swear allegiance to the United States and receive naturalization certificates in front of a federal judge. They also sing the national anthem, watch a color guard present Old Glory, and sign their names on a replica of the Constitution. (Many take photographs next to the statue, too.) Afterward, they can legally vote, serve on juries, apply for passports, and enjoy all other rights and privileges of a US citizen. (Both, KMA.)

Eight

COUNTRY LIVING IN URBAN SETTINGS

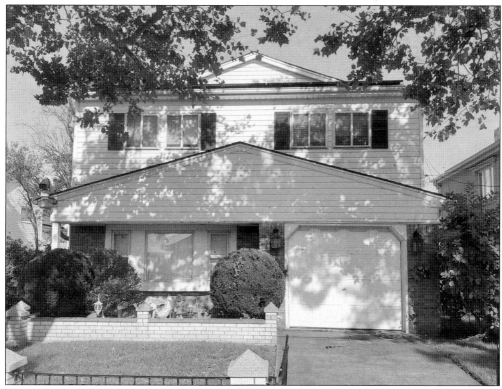

Depending on the source, John Gotti's wealth ranged from $20 million to $123 million. But the alleged one-time Gambino capo raised his family in a modest, two-story Hi Ranch house at 160-11 Righty-Fifth Street in Howard Beach. Built in 1965, the 2,428-square-foot structure sits on a 4,000-square-foot lot with a covered patio and private driveway. Just like when the Bronx-born Gotti lived there, Howard Beach is a middle-class community with a large Italian American population these days. Hi Ranch and Cape Cod homes on 50-by-60-foot lots dominate the flat, suburban landscape, with some cooperative and condo apartment complexes near Jamaica Bay. The area was sparsely populated before William J. Howard built the ritzy Howard Hotel on what is now Ninety-Eighth Street in 1899. The hotel burned down in 1907, but he continued with his development activities, using landfill in marshes, installing water and gas mains, and building 18 cottages. The area was named Howard Beach in 1916. (QTC.)

The "Dapper Don" (1940–2002) was very popular in his neighborhood, where he held a huge annual fireworks show and barbecue every July 4. The feeling was mostly mutual. Neighbors tied yellow ribbons around trees to show support for the silk-suit-wearing mobster in 1992, when he was found guilty of such charges as murder, racketeering, extortion, tax evasion, loansharking, and obstruction of justice. He died of throat cancer in prison. Gotti is seen here dressed in black on his way to visit the grave of his middle son, Frank, on March 4, 1987. Frank darted out from behind a dumpster while operating a motorized minibike near the family house on March 18, 1980. The 12-year-old crashed into a motor vehicle that backyard neighbor John Favara was driving. Police ruled it an accident, but Favara, a service manager at Castro Convertibles who was married with two sons, disappeared four months later. He was declared dead in 1983, but his body was never found. (Associated Press.)

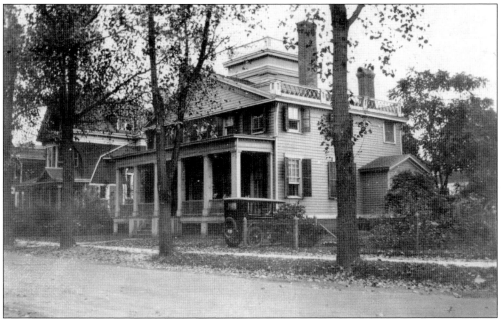

Jeremiah Briggs spent many childhood and early adult years on the sea and never lost his love of the water. Born on Block Island in 1791 or 1792, he captained a gunboat during the War of 1812. After serving his country, he sailed ships all over the world transporting merchandise. Captain Briggs retired to this Greek Revival mansion at 87-27 117th Street in a Richmond Hill orchard. (QPL.)

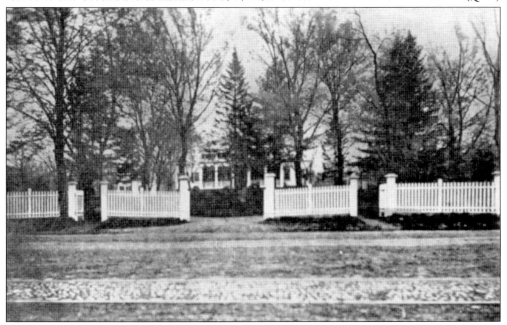

Built in about 1835, the three-story dwelling featured an open porch with six square columns, stained glass windows, and three chimneys. It was huge, but Briggs missed the ocean, so he installed a widow's walk. From this perch, he could watch ships come into Jamaica Bay and New York Harbor with a telescope. He died in 1876 and is buried in nearby Cypress Hills Cemetery on a ridge overlooking the Atlantic. (CB.)

View on the Hill, Richmond Hill, N. Y.
Nr. 10. Published by E. F. Van Sicklen, Richmond Hill, N. Y. Germany

William Sheffield Cowles and his wife, Mary Pleasant, moved into their dream house in 1885. She was Ohio senator Allen G. Thurman's daughter, while he was a deputy commander of the Brooklyn Naval Yard, and they wanted the best. For $30,000, they got a two-and-a-half-story Colonial in Richmond Hill with a glassed-in porch and views all the way to the Fire Island firehouse. Masonry and clapboard were on the outside, while the inside featured woodwork with Georgian and Federal details. The state-of-the-art house had steam heating, which allowed for a Turkish bath that made them the envy of the still-rural neighborhood. At about the same time, the US Navy assigned Lieutenant Cowles to the USS *Despatch*, the official presidential yacht. The world's largest when constructed in 1873, the wooden, schooner-rigged steamship hosted heads of state, royalty, and other world figures. (Both, CB.)

Richmond Hill Drive, Richmond Hill, L. I.

88

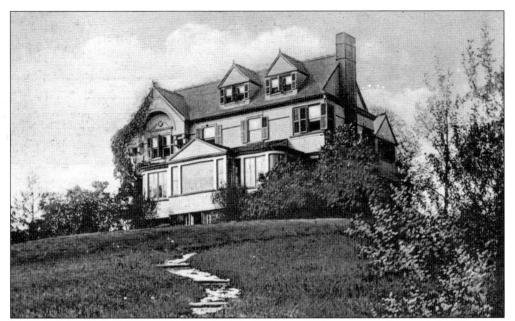

The house must have been haunted. On October 10, 1891, Lieutenant Cowles misread a lighthouse signal off Virginia, and the *Despatch* crashed into a jetty. Water filled the engine room, and the yacht sank. The crew escaped via lifeboats, and the remains were sold for salvage. The president was not on board—the vessel was heading to Washington, DC, to pick him up—but Lieutenant Cowles became a national laughingstock. (CB.)

Then fate took another turn. Lieutenant Cowles was commanding the USS *Missouri* when it collided with the USS *Illinois* in 1903, and again when 33 men died in an explosion in 1904. He was cleared of responsibility, but he never returned to Richmond Hill. Mary abandoned the house and filed for divorce in 1889, eventually settling in California. He died in Farmington, Connecticut, in 1923. (LOC.)

Julius Lang bought the house in 1892. He lived there with his wife, Mathilde, three daughters, and two sons. Julius had made a fortune via the Fuchs & Lang Manufacturing Company, which was a leader in the lithograph industry. After the Langs, the house went through a series of owners before it was razed in the 1930s to be replaced by the six-story, 23-unit Windsor Court apartment complex on 116th Street. These two photographs are from about 1900. The Lang family is in the one below. (Both, CB.)

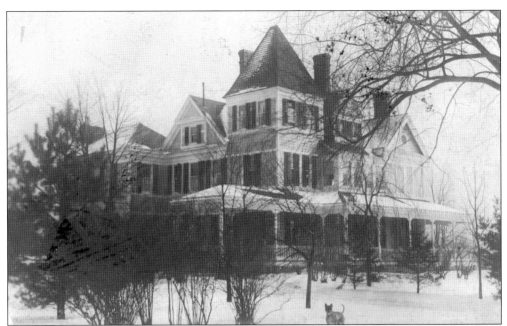

New York City has had three Richmond Hills. The Manhattan original is now the West Village, while its Staten Island cousin is Richmondtown these days. Only the one in Queens has retained the name, which was assigned by the community's main planner, Albon Platt Man. The wealthy Manhattan lawyer fell in love with the area's ocean views when passing through during horse-and-carriage trips to his Long Island summer house. He bought about 400 acres of farmland from the Lefferts, Welling, and Bergen families starting in 1868. He formed a development company and partnered with Oliver E. Fowler to plan tree-lined street grids where a church, school, railroad station, and mostly Victorian houses popped up over the following decades. It is believed Man chose the name Richmond Hill in honor of his family's English town of origin, although his first business partner was Edward Richmond. (Both, CB.)

After Albon Platt Man died on March 30, 1891, his son Alrick Hubbell Man continued the family business and even developed adjacent Kew Gardens with Oliver E. Fowler's son Joel Fowler. Both scions were extremely involved in civic affairs. Alrick held a position similar to mayor of the Village of Richmond Hill before Queens incorporated into New York City in 1898. Joel had a real estate and insurance business and served as an alderman and deputy borough commissioner for public buildings, lighting and supplies. In the above photograph, Alrick sits with his wife, Lucy, and a granddaughter, also named Lucy. (Both, CB.)

Alrick lived in a large Queen Anne mansion with a mansard roof at 83-45 118th Street near Metropolitan Avenue. Joseph Lyman, the agricultural editor of the *New York Tribune*, built the house in 1871, but died from smallpox there a bit later, so people were afraid to visit. The Man house is seen at far right below. It is now a set of apartment buildings, and true to its first owner's profession, it is right at the Kew Gardens–Richmond Hill border. Alrick is standing at left in the photograph above taken at Coney Island. His mother is seated at center. (Both, CB.)

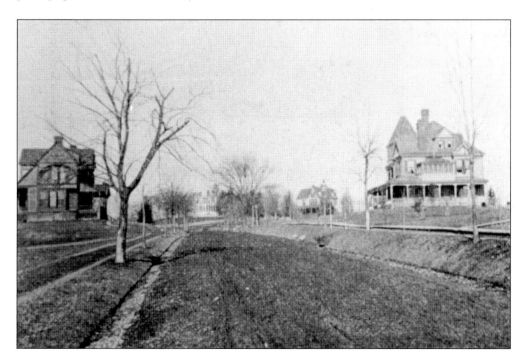

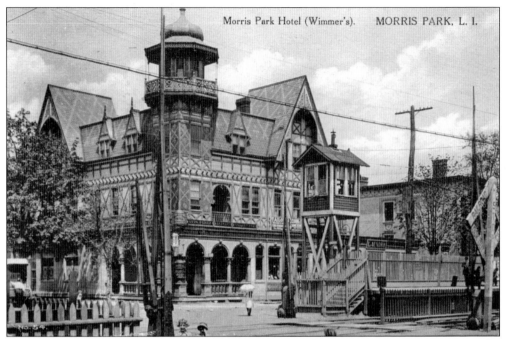

Morris Park Hotel (Wimmer's). MORRIS PARK, L. I.

The Morris Park Hotel was the Magic Kingdom of its time when constructed in the 1890s. The architecture was a cartoonish mix of Tudor, Gothic, and Victorian styles, and a half-timbered façade meshed with a Moorish cupola on the outside. (CB.)

The hotel was on the corner of Atlantic Avenue and Lefferts Boulevard in the Morris Park section of Richmond Hill. Located near a station on the Long Island Railroad's Atlantic Branch, passengers were its main clients, as was true with other local neighborhoods that had railroad stations. The hotel was demolished in 1911 for a gas station, and a police precinct was built in its spot three years later. (CB.)

Born in 1819, Rev. Dr. William Agur Matson had a distinguished career with the Episcopal Church that included stints as secretary of the Western New York State Diocese, recording secretary for the General Board of Missions, and editor of the *Gospel Messenger*. In 1877, he moved to 115-01 Eighty-Fourth Avenue in Richmond Hill to pastor the nearby Church of the Resurrection. Reverend Matson became such a prominent community member that local stores closed for the day when his daughter Katherine married James Post on June 3, 1885. The groundbreaking event was the area's first-ever wedding in a church, as tradition mandated that they take place in the brides' homes. Reverend Matson died in 1904. Katherine (Matson) Post wrote *The Story of Richmond Hill*, a history book which the Twentieth Century Ladies' Club published in 1905. (Both, CB.)

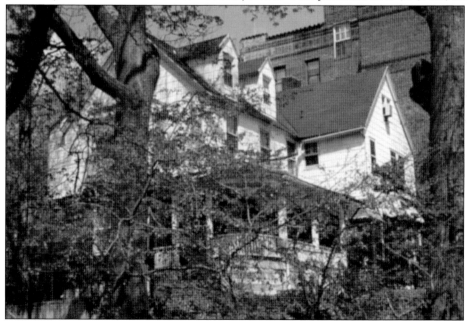

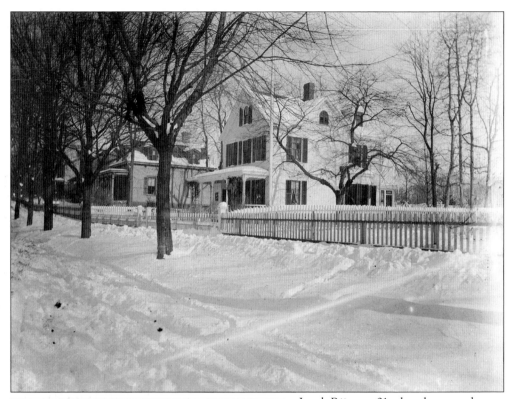

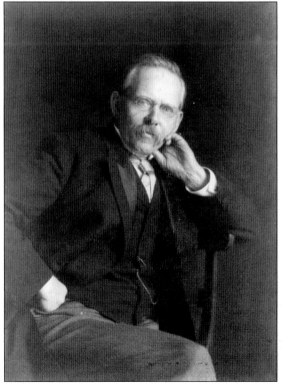

Jacob Riis was 21 when he moved from Denmark to the United States in 1870. He worked as a brick-maker, coal miner, farmer, and peddler before getting a steady job as a police reporter for the *New-York Tribune* in 1887. That led to a widely read column in the *Evening Sun* and various books, such as *The Battle with the Slum* in 1902. His pioneering use of photographs to depict poverty and ghastly social conditions led to such fame that a Queens beach and a Manhattan public housing project bear his name. Riis did most of his writing in Richmond Hill, where he built a two-and-a-half-story house at 84-41 120th Street in 1888. Four bays wide, it featured a gabled roof and clapboard siding. (Both, LOC.)

Riis is with Amos Ensign at the *New-York Tribune* in this 1901 photograph. His coverage of slums attracted the attention of Theodore Roosevelt, who ran New York City's Police Board of Commissioners from 1895 to 1897. Their friendship continued through Roosevelt's rise to New York governor and US president. (He offered Riis jobs in his administration, but Riis turned them down, reasoning that journalism was his calling.) (LOC.)

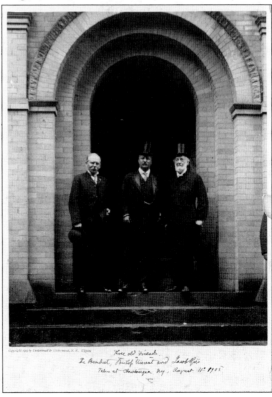

Governor Roosevelt attended the Richmond Hill wedding of Riis's daughter Clara to Dr. William Fiske in 1900. The elected official escorted Elisabeth down the aisle, arm-in-arm. Three years later, President Roosevelt made his first official speech to more than 2,000 people in a Richmond Hill depot. (He praised Riis to the crowd.) This 1905 photograph shows the old friends with Methodist Episcopal bishop John Heyl Vincent in the upstate New York resort town Chautauqua. (LOC.)

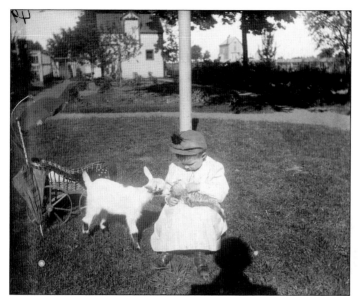

A Riis daughter plays with a cat and a baby goat on the family's Richmond Hill property in this 1888 photograph. The house in the background became a National Historic Landmark in 1968, but the designation was withdrawn in 1973 because dilapidation had ruined the dwelling's structural integrity. The site is now a row of attached redbrick houses. (LOC.)

This is the one-room study where Riis wrote *How The Other Half Lives*, an exposé of New York City's slums that was full of unapologetic, harsh criticism of high society. It sparked many reforms aimed at improving conditions in poor neighborhoods, including the 1895 New York Tenement House Act, which increased fire safety regulations, ventilation rules, and room space requirements, among other dictates. Riis commissioned the study to have a gabled roof and clapboard siding that matched the main house. (CB.)

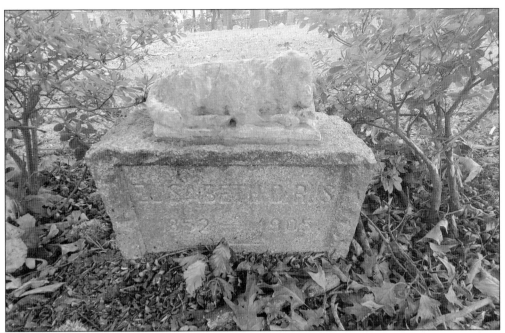

It is basically unknown, but Riis brought the Danish tradition of Christmas caroling to the United States. During a 1911 Christmas Eve service at the Church of the Resurrection, Riis noticed that regular parishioner Ella Flanders was absent due to sickness. Later that day, Riis visited his wife, Elisabeth's, grave (above) in Maple Grove Cemetery, as he often did. Paying respects made him think about his homeland's caroling tradition. He then organized a group of roughly 30 locals, including Alrick Man, to go to Flanders's house and sing as she reposed before heading to other houses. The response was tremendous, and neighbors demanded a repeat the following year. The grave is between two beeches that Riis planted to honor Elisabeth. The trees and bench where he probably got the idea for caroling are below, with the grave in the background. (Both, QTC.)

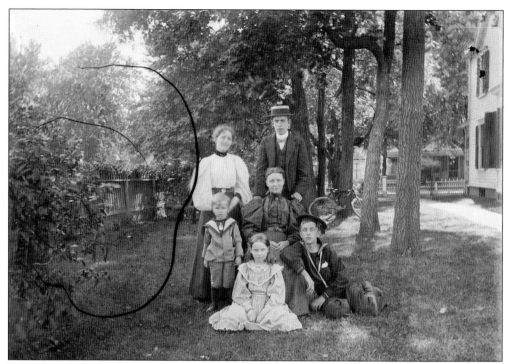

The photograph above was taken on the Richmond Hill property in the summer of 1888. Elisabeth is sitting in the middle, surrounded by their five children. The family would frequently bring groups of poor children from tenements to their place for a day in the country during the warm months. The 1890 photograph below shows two unidentified people in front of the Riis house. Melting snow has created a little pond. (Both, LOC.)

Nine

PLANNED COMMUNITIES

Streets are often given notable people's last names, but one major Forest Hills thoroughfare derives from a remarkable resident's first name. The story begins in the Kingdom of Saxony (modern-day Germany), where Ascan William Christian Backhaus was born in 1814. He followed an older brother, Charles, to the United States at age 15, finding work on a farm in Woodside. Hardworking and frugal, he slowly saved money and eventually owned more than 800 acres and four wagons. People called him "King Farmer" because he supplied provisions, mainly potatoes, to Northern troops during the Civil War. Backus (note the spelling change) built a large wood-frame, white-shingled house at what is currently 104-55 Queens Boulevard (pictured in 1922). The neighborhood, which was called Whitepot at the time, had about 25 residents spread out over five other farms owned by Sarah V. Bolmer, Abram V.S. Lott, James Van Siclen, Casper-Joost Springsteen, and Horatio N. Squire. Backus had two sons. The elder, John, who was born in 1846, became the borough's first deputy bridge commissioner and helped construct what is now the Ed Koch Queensboro Bridge in 1909. Frederick, who was four years younger, joined forces with German immigrant Cordt Meyer to build houses in 1897 as the farming community was transitioning to a suburb. They changed Whitepot to Forest Hills in 1906 partly because of the neighborhood's proximity to Forest Park and partly due to its high elevation, but mostly for marketing purposes, as they had houses to sell. (QPL.)

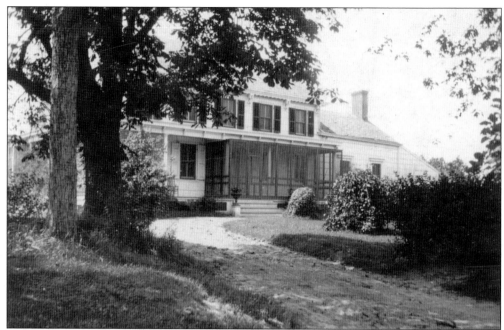

As president of the Cord Meyer Development Company, Frederick created a road between Queens Boulevard and Metropolitan Avenue in 1909. He named it Ascan Avenue after his father. Frederick died in the family homestead on February 14, 1937. He had two children, Ascan II and Wilhemina, but both died childless in the 1940s. In 1950, a fire destroyed the house, which was razed and replaced by a shopping center that is still there today. As seen below, a portrait of Ascan Backus is part of a mural on Ascan Avenue under the Long Island Railroad overpass near Austin Street. He is between local philanthropist Margaret Sage and urban planner Grosvenor Atterbury. An image of the Backus family barn is also on the mural, which street artists Crisp and Praxis created in 2017. (Above, Jeff Gotlieb and Queens Community Board 6; below, QTC.)

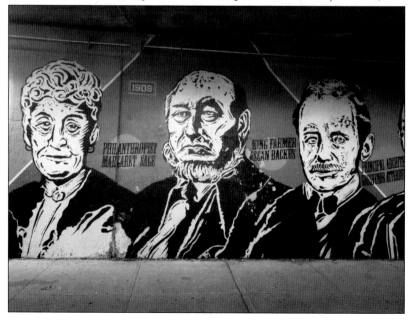

Dale Carnagey was born into rural poverty in Missouri on November 24, 1888. After graduating from what is now the University of Central Missouri, he made good money selling everything from bacon to soap. He moved to New York City to try acting, but lost his savings. In despair, he negotiated a deal with a YMCA that allowed him to live on-site provided that he teach courses. Carnegie, who changed the spelling of his last name in 1922, published *How to Win Friends and Influence People* during the Great Depression in 1936. The self-help book extolled the benefits of being considerate, sincerely listening to differing viewpoints, demonstrating interest in others, and thinking positively. The instant success remained on bestseller lists for almost a decade and catapulted Carnegie to a career as a lecturer, television guest, author, and founder of the Dale Carnegie Institute. Along the way, he bought a house at 32 Wendover Road in Forest Hills, where he lived until his death on November 1, 1955. This picture is from 1939. (Jeff Gotlieb and Queens Community Board 6.)

During World War I, Albert Phelps Armour (1882–1960) built airplanes. After the truce, he helped invent folding telephone booths with the Turner-Armour Company, which he had founded with Kew Gardens resident Maurice Turner. (They eventually sold the patent to Western Electric Company.) From there, the entrepreneur manufactured a submarine battery, created the first ignition battery for motor vehicles, and oversaw the construction of his 65-foot schooner, *Alpha*. In 1927, Armour built Granston Tower at 123 Greenway South in Forest Hills. Designed by Douglass Fitch, the Norman and Tudor Revival brick mansion had 14 rooms. Trygve Halvdan Lie (1896–1968) had similar energy. The Oslo native had already been a labor leader, member of parliament, foreign minister, trade union advisor, and author before serving as the first-ever secretary-general of the United Nations from 1946 to 1952. From the beginning of his term through 1953, he lived at Granston Tower with his wife, Hjordis Joergensen, and their children Sissel, Guri, and Mette. Asked about his future in an exit interview with the *New Yorker*, he replied, "I'm going to miss Granston Tower." (QTC.)

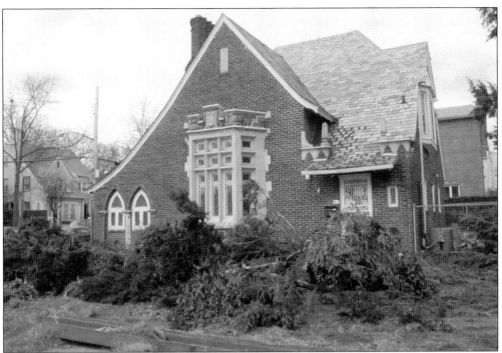

The first openly Jewish entertainment star in the United States was born Asa Yoelson in Lithuania in 1886. At age eight, his father, Rabbi Moseh Reuben Yoelson, brought the family to Washington, DC. Al Jolson literally ran away with a circus, ending up in New York City with his brother Harry. He rose through vaudeville as a comedian and singer who could whistle loudly and make dramatic facial expressions. He had a long Broadway career and starred in the first talking movie ever made, *The Jazz Singer*, in 1927. Jolson owned a Tudor Gothic house at 68-12 110th Street in Forest Hills. Built around 1925, it featured a brick façade, stained-glass bay window, corbelled chimney, and flagstone-sloped roofline. It was demolished despite landmarking efforts, and a McMansion quickly went up on the property. In 1982, police arrested 14 people for operating a casino there. They seized a dice table and two blackjack tables and described a large photograph of Jolson hanging over a huge fireplace in the main gaming room. The image below was captured in 1923. (Above, Jason Steinberg; below, LOC.)

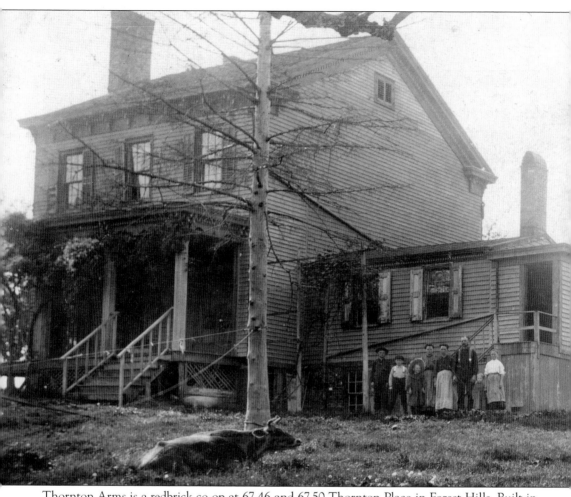

Thornton Arms is a redbrick co-op at 67-46 and 67-50 Thornton Place in Forest Hills. Built in 1963, the two six-floor towers have 112 apartments and several hundred residents. For about 150 years, the property had the addresses Fleet Street, 108 Whitepot Road, and Springsteen Lane. Its main feature was a two-story, porch-fronted frame farmstead with a cornice and pitched roof. It was called Jürgens Farm, and members of the same family worked the land there ever since Henry Jürgens and his wife, Charlotte, arrived from Germany in 1906. The house's luxuries included a kitchen with a coal stove, a storage cellar, and a potbelly stove to heat the second floor. Rustic latrines had telephone books or Sears catalogs inside, as toilet paper was not common. A developer purchased the property after the final Jürgen moved out around 1960. This led to Thornton Arms, whose lobby boasts a gallery with large prints of restored photographs from Jürgens Farm dating from as far back as the 1910s. (Darren and Veronica Jürgens.)

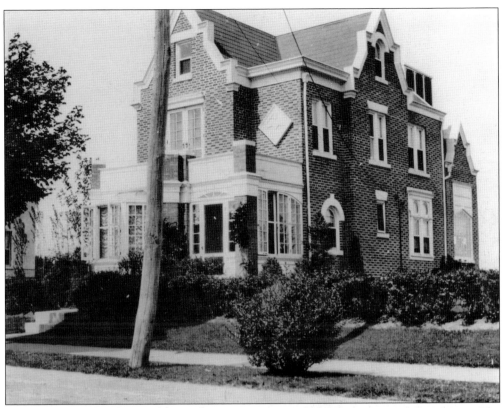

Though severely handicapped by scarlet fever when only 19 months of age, National Women's Hall of Fame inductee Helen Keller was an internationally respected suffragette, disability activist, author, and lecturer. She was also the first deaf-and-blind person to receive a Bachelor of Arts degree from Radcliffe College (magna cum laude), a co-founder of the ACLU, and an early NAACP supporter and donor. (Michael Perlman.)

Though born in Alabama in 1880, Keller grew up in a brick house at 112th Street and 71st Road in Forest Hills, where her family lived from 1917 to 1938. She called it "Castle on the Marsh," and it is where she learned Braille and lip-reading with Anne Mansfield Sullivan, also known as "the Miracle Worker." Sullivan, who was partially blind as well, lived with Keller. The close companions worked together on many of Keller's books and speeches. (LOC.)

HELEN KELLER & MRS. MACY

Castle on the Marsh was a hotbed of activism, as Keller's family had a de facto open-door policy for friends, colleagues, and community groups, especially members of the 42nd Infantry Division of the US Army, which Gen. Douglas MacArthur called the "Rainbow Division." Keller held many fundraisers for the American Foundation for the Blind and other charities there, and organized large birthday parties for the blind on her front lawn. Robert Hof grew up next door. He donated the photograph above, which includes Keller and some of his family members. (Above, Robert Hof; below, Michael Perlman.)

Castle on the Marsh burned down after the family had moved out, and the Reform Temple of Forest Hills currently operates on the site. (Keller died in Connecticut in 1968.) A plaque on the synagogue's front wall educates passersby about Keller, as does a mural on the west wall of the Ascan Avenue train overpass. It is across the roadway from the Backus mural and was created by the same two artists, Crisp and Praxis, after an effort spearheaded by Rego-Forest Preservation Council chair Michael Perlman. The 48-foot-wide, 4-foot-tall painting features images in black, white, and metallic gold that depict her life, along with her famous quote, "The only thing worse than being blind is having sight but no vision." Perlman also provided the previously mentioned Jürgens Farm images in the Thorton Arms lobby. (Both, QTC.)

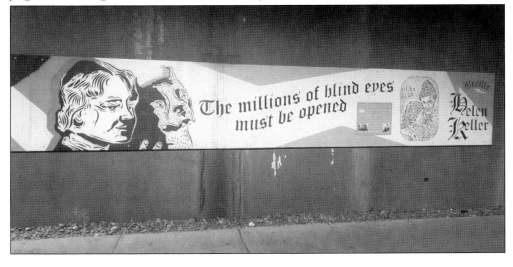

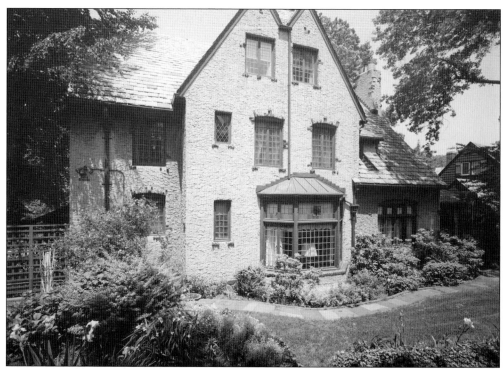

In 1952, United Nations undersecretary-general Ralph J. Bunche bought a two-and-a-half story, Neo-Tudor house in Kew Gardens. Built in 1927 as part of a first-time neighborhood development and designed by prominent Brooklyn architects Koch & Wagner, the residence is faced in stucco with ashlar stones and pierced by random bricks and stones. It has wooden doors with iron strapping, wooden half-timbering near the tops of the gables, an open stone porch, and a terraced flagstone walkway. A one-story, stone-faced sunroom with floor-to-ceiling casement windows is on one side. (Both, LOC.)

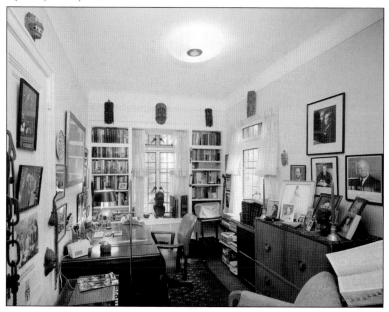

For negotiating peace deals with Palestine after Israel was established as a nation in 1948, Bunche became the first African American to win a Nobel Prize, in 1950. The long-serving diplomat also received a Medal of Freedom from Pres. Lyndon B. Johnson and a Presidential Medal of Freedom (the highest civilian honor in the United States) from Pres. John F. Kennedy. Bunche was so famous that the Kew Gardens house's previous owner, Jack Strum, lowered his offering price because he was such a fan. The above photograph shows how Bunche extended the house. The photograph below is from the Arab-Israeli armistice dialogues in 1949. (Above, LOC; below, USNA.)

Bunche resigned from the United Nations due to bad health in 1971 and died the same year, but his family lived in Kew Gardens until his widow, Ruth Ethel (née Harris), died in 1988. Due to Bunche and the fact that the neighborhood was integrated decades before most others in the United States, the home was declared a National Historic Landmark in 1976. It obtained New York City landmark status in 2005. (LOC.)

In the photograph at the top of this page, Bunche arrives in what is now Kinshasha, the capital of the Democratic Republic of the Congo, in December 1961. He negotiated a transition to self-determination after Belgium granted independence to the African nation in 1960. Here, he is with Archbishop Makarios III, the president of Cyprus, in Nicosia in 1964. At the time, Nicosia's Turkish and Greek sections were segregated during a military crisis. (United Nations.)

James E. Ware was one of New York City's most prominent architects in the late 1800s. He designed Manhattan's first luxury building, the Osborne Apartments, and iconic resort hotels such as Mohonk Mountain House. He was also a trustee of Maple Grove Cemetery, which opened in Kew Gardens in 1875. For $100 and a 12-person plot, Ware designed the lodge, which A. Van Dien built inside the 65-acre graveyard a year later. (CB.)

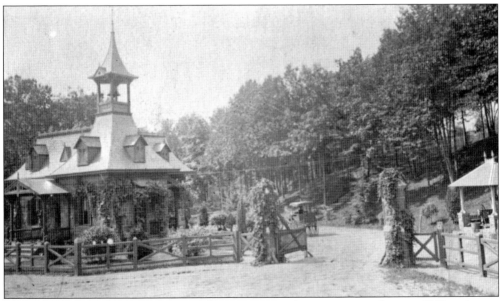

Near the Queens Boulevard entrance, the two-story, multi-use structure (seen in 1908 at the top of the page and in 1897 here) featured a bell tower, dormers, and a slate roof. It was the home and office for Maple Grove's superintendent and his family, but it also had a waiting room for visitors and funeral attendees. The building's layout made it difficult to incorporate modern-day amenities, and it was demolished in the 1930s. (CB.)

Representatives of foreign governments from all over the world wanted to move to Queens after the United Nations started operating in Flushing Meadows Corona Park in 1946. However, most of the borough's real estate was racially segregated, with covenants restricting sales to non-whites in some places. Plus, there was a national housing shortage. (QTC.)

After negotiations with master urban planner Robert Moses and Mayor William O'Dwyer, the United Nations signed a lease with Parkway Village, which was under construction at the time. In 1947, the complex opened with more than 650 units spread over 37 acres in the vicinity of Main Street, Grand Central Parkway, and Parsons Boulevard in Briarwood. (QTC.)

The integrated community had a mix of two-story and three-story buildings designed by Waldorf-Astoria Hotel architect Leonard Schultze in a neo-Georgian or modernized Colonial style. As seen in the 1947 photograph above, the 109 concrete buildings were faced with red brick, adorned with white columns and lintels, and surrounded by green spaces and a public square in a "Post-War Garden" layout. Robert Moses, known as the "Power Broker" and "Master Builder," stands by a proposed Battery Bridge model in the 1939 photograph below. At one point, he had 12 simultaneous job titles, including NYC Parks commissioner, New York secretary of state, and Long Island State Park Commission chairman. Without his support, there would probably be no Parkway Village. (Both, LOC.)

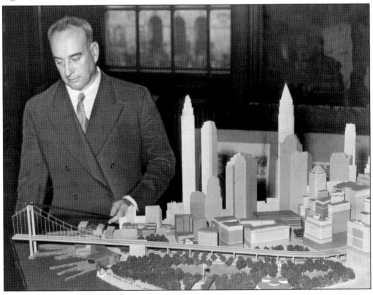

The photograph to the left shows a United Nations session in what is now Queens Museum in Flushing Meadows–Corona Park. As per the agreement, only members of the diplomatic corps and war veterans could rent Parkway Village units at first. Thus, Nobel Prize–winning diplomat Ralph Bunche lived there from 1947 until 1952, when he bought his Kew Gardens house. In 1952, the United Nations relocated to its present-day headquarters in Manhattan's Turtle Bay, spurring an exodus from Parkway Village. The management association continued its non-discrimination policy, and NAACP leader Roy Wilkins and National Organization for Women co-founder Betty Friedan (below) lived there in the 1950s. Although it does not have New York City landmark status, it was listed in the National Register of Historic Places in 2012. (Left, NYC Parks; below, LOC.)

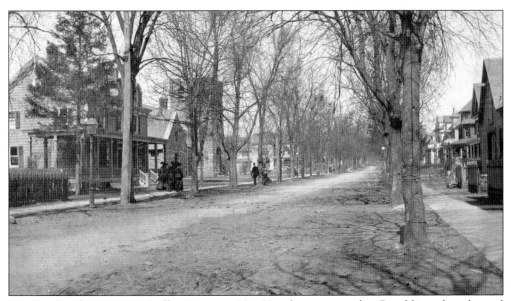

In 1660, Dutch immigrant Leffert Pietersen Van Haughwout arrived in Brooklyn, where he and his wife raised 14 children. Over the next two generations, the family took the Lefferts surname and became extremely wealthy and influential in the borough. One signed the Declaration of Independence, while others were doctors, engineers, judges, military leaders, and elected officials. But the Lefferts family has a long and distinguished history in Queens, too. (CB.)

John Lefferts bought roughly 200 acres in the Woodhaven/Richmond Hill area in about 1850. He built the unique three-story Lefferts Farm Cottage, which contained parts from an old ship. A semi-circle arch of bushes led to the entrance, which had square columns in a style that defied convention. In 1868, Albon Man purchased the Plank Road property and relocated the house to 115th Street off Jamaica Avenue, where it still stands. (CB.)

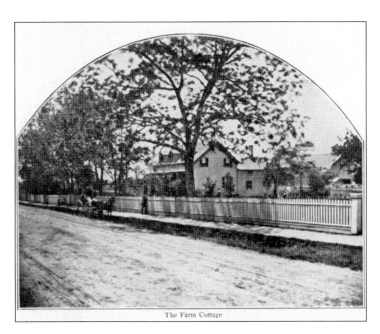

The Farm Cottage

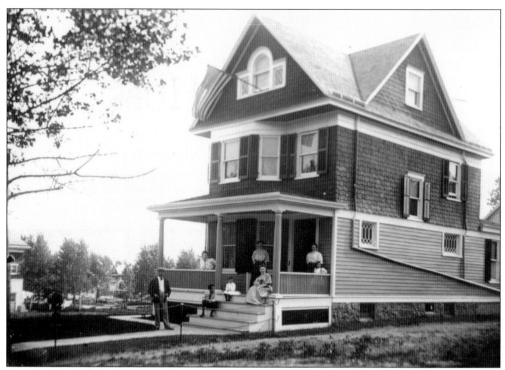

These images show the Olney house, which was built in 1893 in what is now the vicinity of Park Lane South and 108th Street in Richmond Hill. Still around today, it features Victorian furnishings and pocket doors. It was state-of-the-art for luxury living at the time, with patterned rugs, parquet floors, upholstered chairs, chandeliers, and the biggest status symbol of the day, a piano. (Both, CB.)

Ten

CULTURAL HUBS

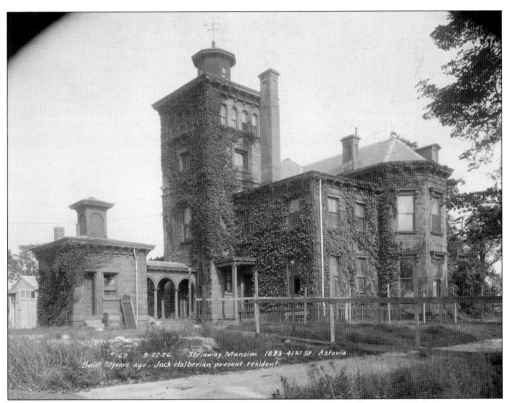

Benjamin Pike Jr. founded a scientific-device company in Manhattan in 1806. Over time, it became one of the country's preeminent manufacturers of corrective eyeglasses and microscopes. He rewarded himself by building a 27-room, granite-and-bluestone Italianate villa on a 440-acre estate on Long Island Sound in Astoria in 1858. (The architect is unknown.) The 2,285-square-foot mansion, seen here in 1926, had a slate gable roof, large bay windows, a four-story tower topped by a balustrade and octagonal cupola, and three porches with cast-iron Corinthian columns. The inside featured a one-story library with floor-to-ceiling carved bookshelves, five Italian marble fireplaces, one coal-burning fireplace, carved walnut balustrades, and a two-story domed rotunda with a stained-glass skylight. Sliding parlor doors, which held original cut glass depicting some of Pike's scientific devices, opened into a formal dining room. There were three underground cisterns to collect rainwater, and a copper tank in the attic provided a pressurized water system. (NYMA.)

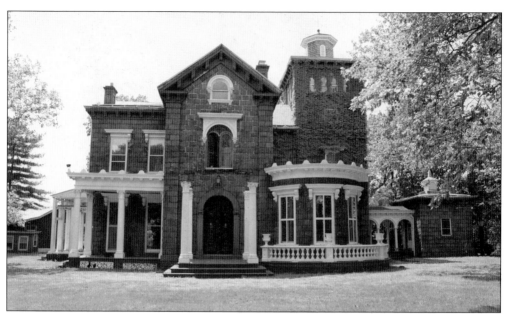

After Pike died, his widow sold the property to William Steinway, who owned the local piano factory Steinway & Sons, in 1870. The next resident was Jack Halberian, a restaurant owner who lived there from 1926 to 1976. The property (upper right below) lost significant value during the Depression when a wastewater treatment plant was constructed nearby, and Halberian had to rent out rooms to pay the expenses. Later, the Greater Astoria Historical Society formed the Friends of Steinway Mansion to raise money to convert it to an educational facility, but undisclosed buyers purchased it in 2014. Currently, its future is unsure, but it has had New York City landmark status since 1966, and was listed in the National Register of Historic Places in 1983. (Above, GAHS; below, NYSA.)

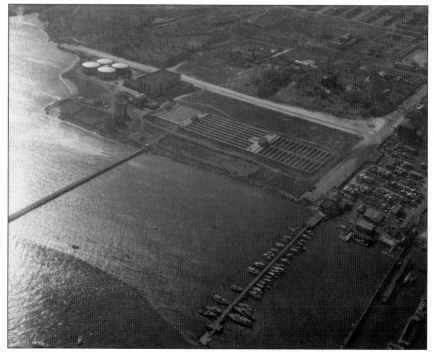

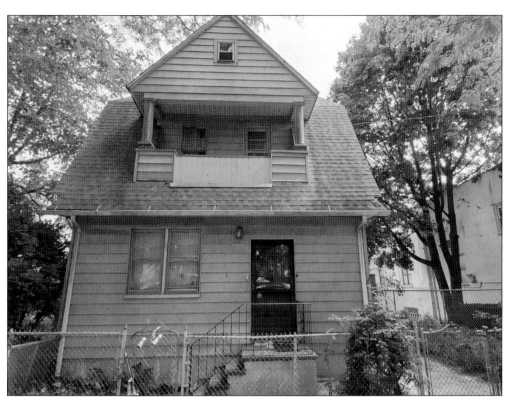

Born in 1913, Walentyna Stocker grew up in a Polish-speaking family in what was the Austro-Hungarian Empire. She was studying English in London when Adolf Hitler's troops invaded Poland in 1939. Soon thereafter, Gen. Władysław Eugeniusz Sikorski, prime minister of the Polish government-in-exile, hired her as his secretary as he plotted to take the country back from the Nazis. In 1947, she fled to New York City, where she married writer Aleksander Janta-Polczynski. They ran a Manhattan bookstore and lived in at 88-32 Forty-Third Avenue in Elmhurst. Built in 1930, the two-and-a-half-story dwelling was the epicenter of Polish expatriate social life, with such visitors as Nobel Prize winner Czeslaw Milosz and *Kultura* magazine editor Jerzy Giedroyc. Walentyna, who lived until 2020, was lovingly called the "First Lady of American Polonia." (Above, QTC; right, Karolina Rostafirski Merk.)

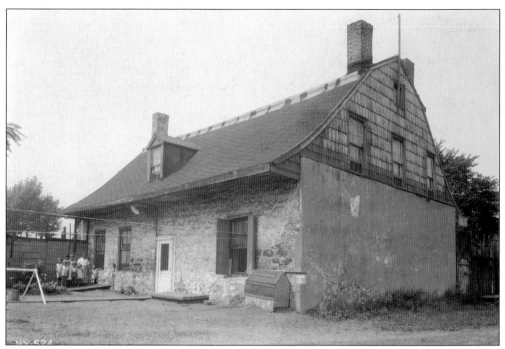

The Vander-Ende Onderdonk House is the oldest Dutch Colonial stone house in New York City. In 1661, Hendrick Barents Smidt built the original structure, which Paulus Vander-Ende enlarged in 1709. Then, Adrian Onderdonk added a wooden wing when his family purchased the property in the early 1800s. With federal, state, and city landmark status, the abode's features include heavy fieldstone walls, a wooden-shingle gambrel roof, large brick chimneys, double Dutch doors, and shuttered windows. The house was abandoned in the 1970s and almost destroyed by a fire in 1975. The blaze inspired the founding of the Greater Ridgewood Historical Society, which took over the estate and opened the house to the public as a museum in 1982. (Both, LOC.)

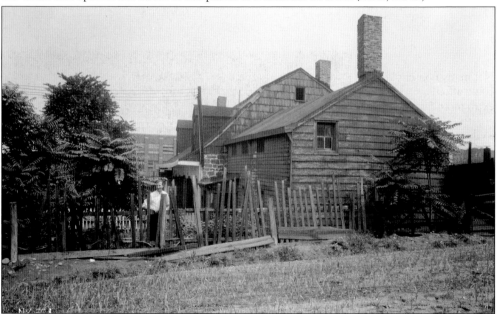

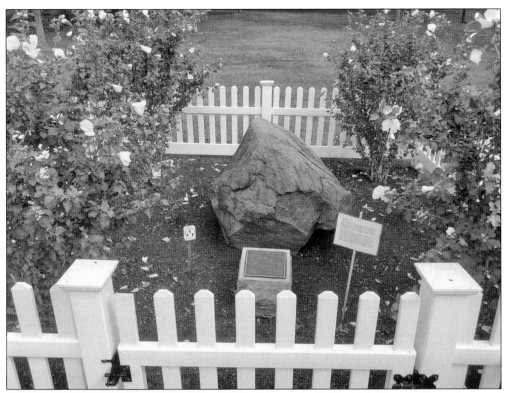

Protected by a white picket fence, Arbitration Rock lies in Onderdonk's backyard. About the size of a Volkswagen Beetle, historians say that surveyor Peter Marschalk used the unevenly-shaped glacial deposit to delineate the border between what is now Brooklyn and Queens in 1769. (They were the towns of Bushwick and Newtown back then.) It was moved in 1930 after nearby Onderdonk Avenue was extended, so it is no longer an accurate border marker. (QTC.)

Not many households could afford an extra room just for entertaining at the time, so the Victorian parlor was the family's pride and joy. It had their most prized possessions, such as the melodeon, and was used for parties, holidays, and guests. The area's other farming families congregated in this room to have fun and play parlor games such as charades and I spy. (LOC.)

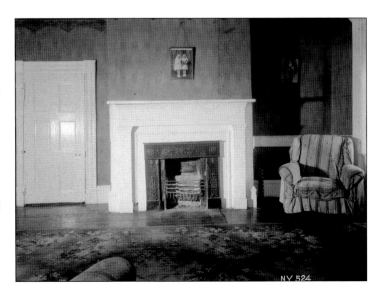

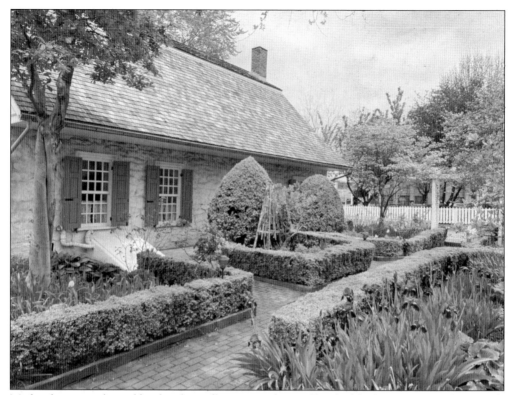

Made of rustic rocks and bricks, the walls are very dense. The double doors are typical of Dutch Colonial architecture. By opening the upper one, light and air enter the house, while the closed lower one blocks farm animals, little children, and rats. The small windows can be closed with shutters. (GRHS.)

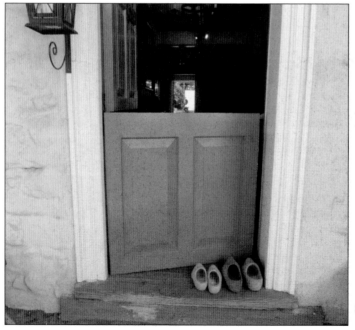

Between 1997 and 1986, archeologists and volunteers dug up the land around the house. They discovered large ceramic pieces, clay pipes, porcelain, and a small amount of leather, metal, and wood. They also found bottles and jars that were probably used for beer, butter, dried fruit, eggs, ink, medicine, nuts, oil, perfume, vinegar, and wine; some dated to the late 1800s. (GRHS.)

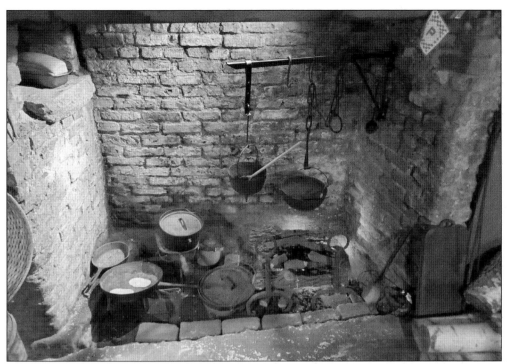

As was common at the time, the kitchen (above) was in the basement. It was hot and smoky most of the year, and servants and slaves lived there, although the family might have slept there during cold spells. Women started their days by making dough and baking bread in a beehive oven. Rye, dark whole grain, and sourdough were the most common kinds, and *koetje*, a flat, hard gingerbread cake, was a popular treat. To be safe, chefs would hang pots on chimney cranes and swing metal arms attached to the inside of the hearth. They swung outward so women could take the pots out of the direct fire to fill and empty them. The gambrel roof (below) has a lower, steeper slope and a higher, flatter slope on the sides. The floorboards, posts, and beams are wood. (Above, QTC; below, LOC.)

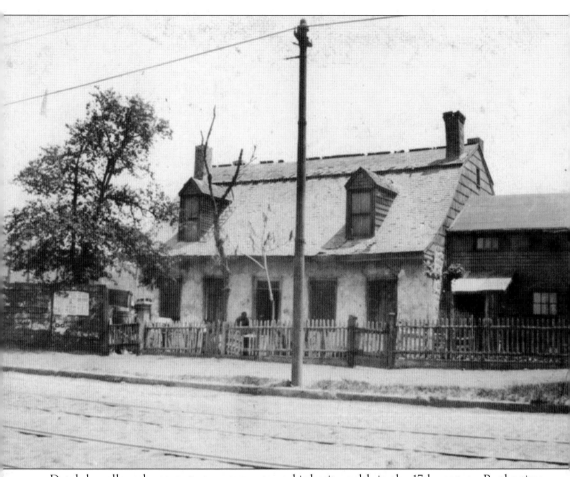

Dutch law allowed women to own property and inherit wealth in the 17th century. By the time the Vander Ende family purchased the estate, Dutch law had given way to British colonial law, which did not give women as much power and freedom. Nevertheless, Dutch customs prevailed in many households, and the Onderdonk property had five female owners—Anna Eliza Colyer, Jannetje Vander Ende, Ann Wyckoff Onderdonk, Gertrude Onderdonk Schoonmaker, and Louise Gmelin—over about two centuries. Two of them, Ann and Gertrude, were widowed with young children, but the single mothers managed the farm and participated in various business ventures while raising their families. The female entrepreneurs ran a livery, a stable, and a scrap glass factory (basically a recycling plant) on the property. They would collect broken glass from the local Rheingold and Schaefer breweries and knitting mills and the Tiffany lamp factory in Corona. The New York Married Women's Property Act, which granted women the right to sole ownership of property, was passed in 1848. (GRHS.)

Archie Bunker was the main character in *All In the Family*, a sitcom that CBS broadcast from 1971 to 1979 to as many as 50 million weekly viewers. He was racist, sexist, anti-Catholic, anti-Semitic, anti-immigrant, and big-mouthed. He also lived in Queens. As Archie would retort, "Puh-lease!"—Hollywood was completely wrong on this one. First of all, the show was filmed about 3,000 miles from multicultural, tolerant Queens in California, where the writers and actors were. Second, the Bunkers allegedly lived at 704 Hauser Street in Astoria, an address that does not exist. (Interestingly, CBS had offices on Hauser Boulevard in Los Angeles.) If that is not enough, when Archie and his wife, Edith, sing "Those Were the Days" during the credits, the camera pans to this house at 89-70 Cooper Avenue in Glendale, about 10 miles from Astoria. (QTC.)

Discover Thousands of Local History Books
Featuring Millions of Vintage Images

Arcadia Publishing, the leading local history publisher in the United States, is committed to making history accessible and meaningful through publishing books that celebrate and preserve the heritage of America's people and places.

Find more books like this at
www.arcadiapublishing.com

Search for your hometown history, your old stomping grounds, and even your favorite sports team.

Consistent with our mission to preserve history on a local level, this book was printed in South Carolina on American-made paper and manufactured entirely in the United States. Products carrying the accredited Forest Stewardship Council (FSC) label are printed on 100 percent FSC-certified paper.

MADE IN THE USA